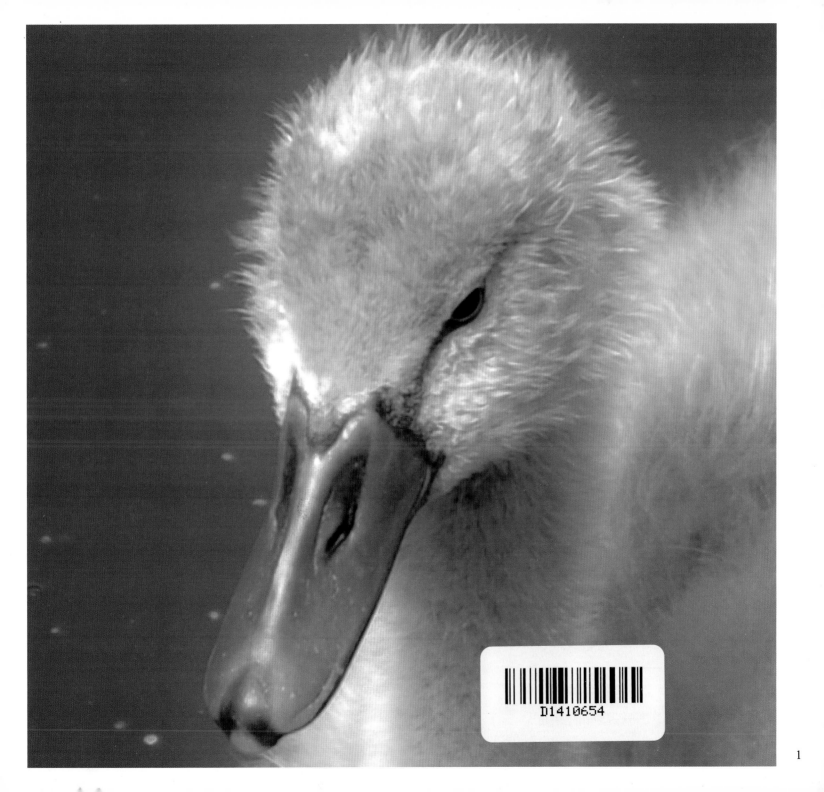

1

Published by
REARDON PUBLISHING
PO Box 919, Cheltenham, Glos, GL50 9AN. Email: reardon@bigfoot.com tel: 01242 231800
Copyright © 2014 Reardon Publishing

Photographs © Copyright
Nicholas Reardon

ISBN 1874192790
ISBN (13) 9781874192794

Written, Designed and illustrated
by
Nicholas Reardon

The Cotswolds

These glorious hills, rightly described as an area of outstanding natural beauty, contain a treasure trove of spectacular views, along with flowers and wildlife just asking to be photographed.

In the following pages I take you through the seasons, offering just a taste of what can be seen, in the hope that it will tempt you to explore this wonderful countryside for yourselves.

From hidden gems like the stone crocodile head on a fresh water spring in Compton Abdale, and fearsome gargoyles staring down at you from ancient churches, to the grandeur of castles and the splendour of stately homes, I hope to bring the Cotswolds alive for you with the help of my camera.

So as not to spoil the images with excess wording I have let the pictures speak for theirselves but at the back of the book you will find a page-by-page explanation of the photographs, along with the locations.

This book was made possible by the help and kindness shown to me by the various attractions, allowing me to roam freely over their properties in search of interesting views, fascinating artefacts and plentiful wildlife.

Lastly I wish to thank my wife, Sally, who encouraged me to take up photography and so made this book possible.

Nicholas Reardon

Spring

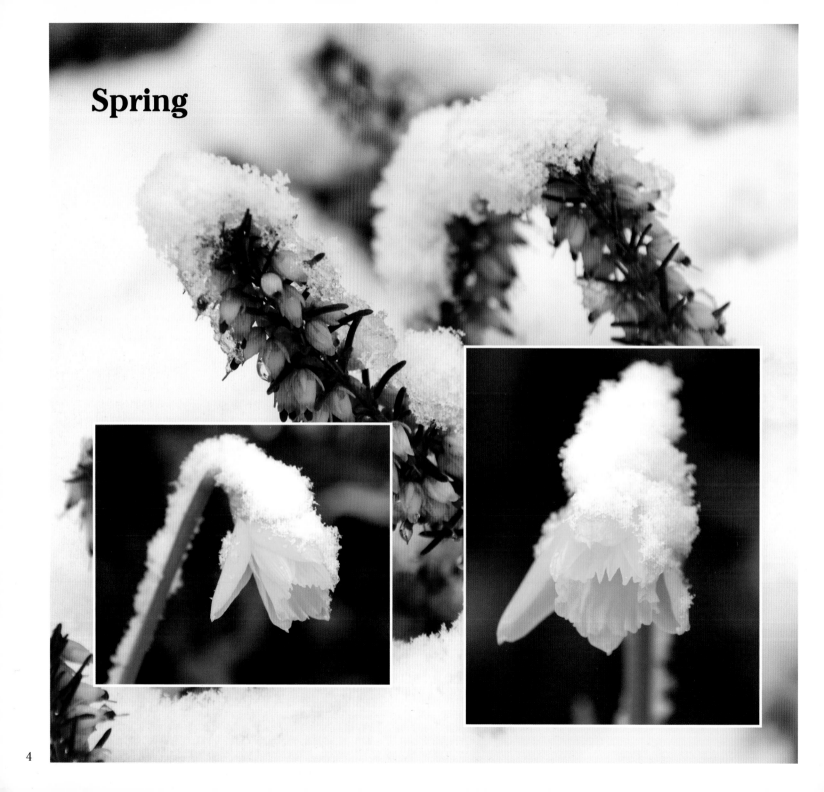

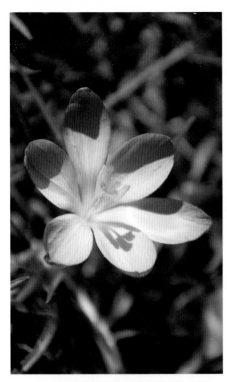
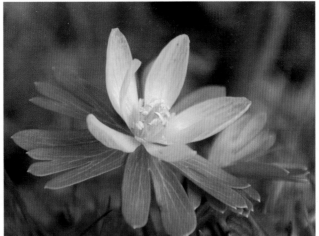
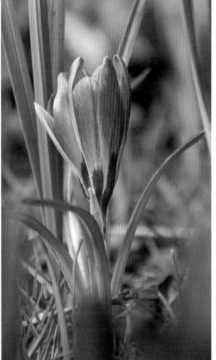
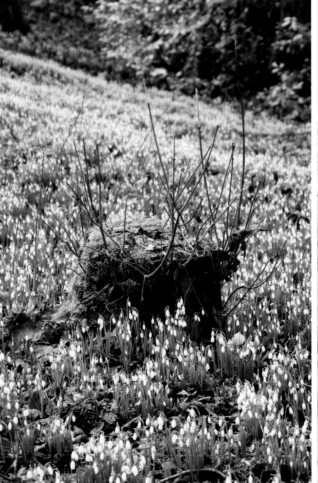
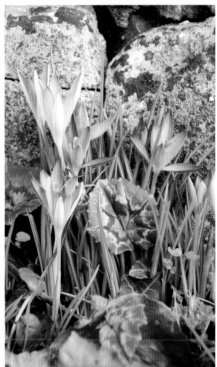

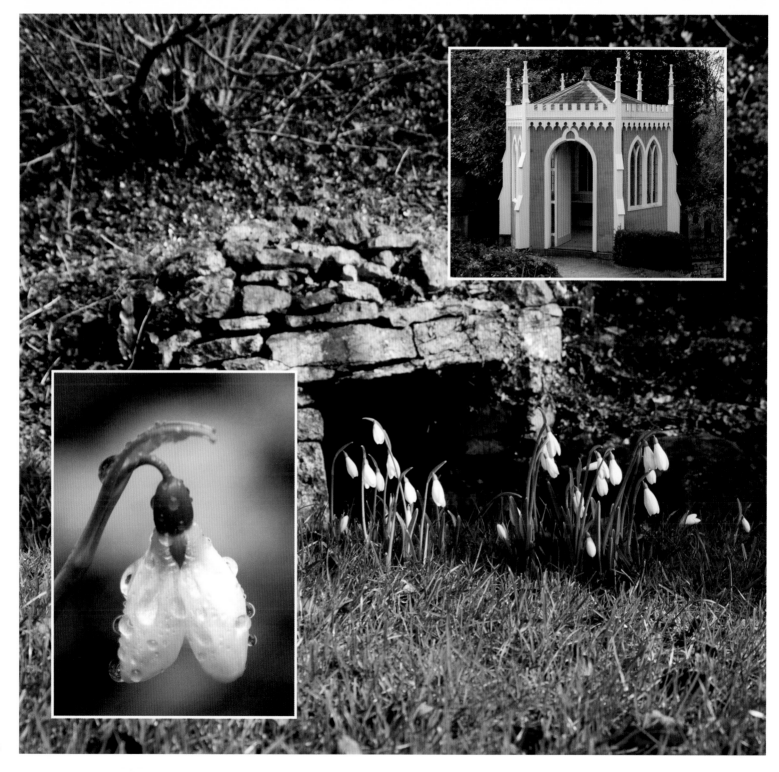

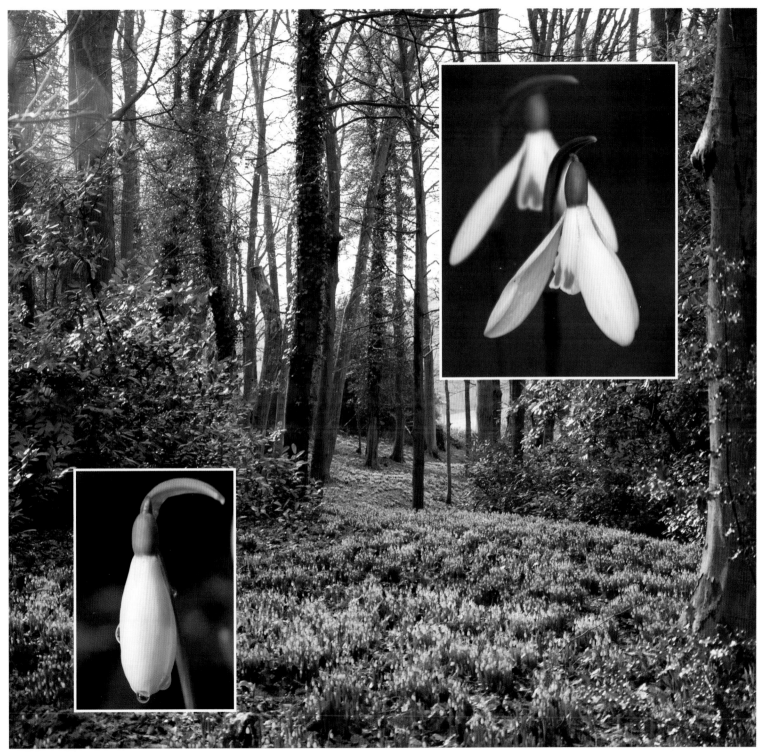

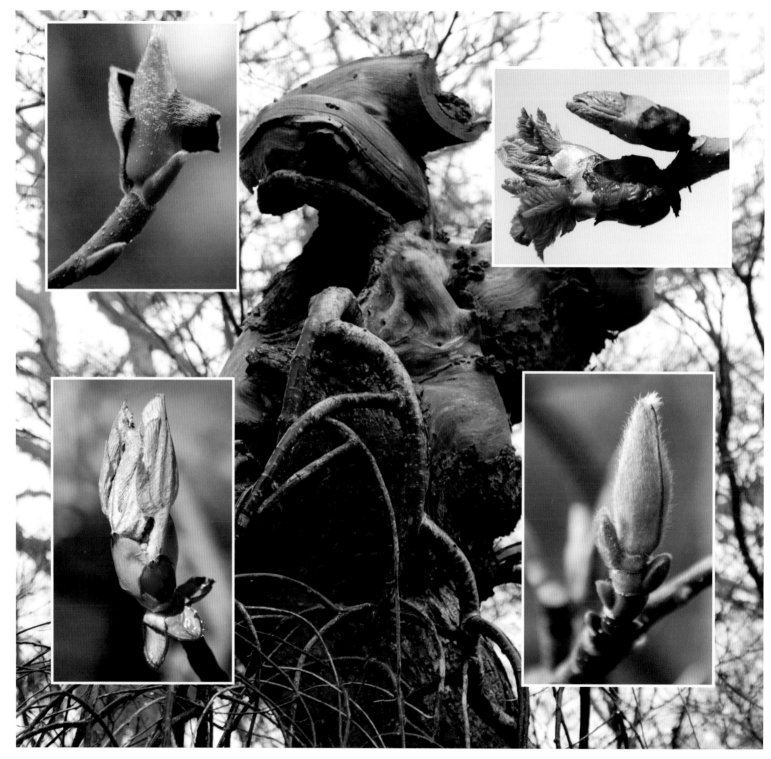

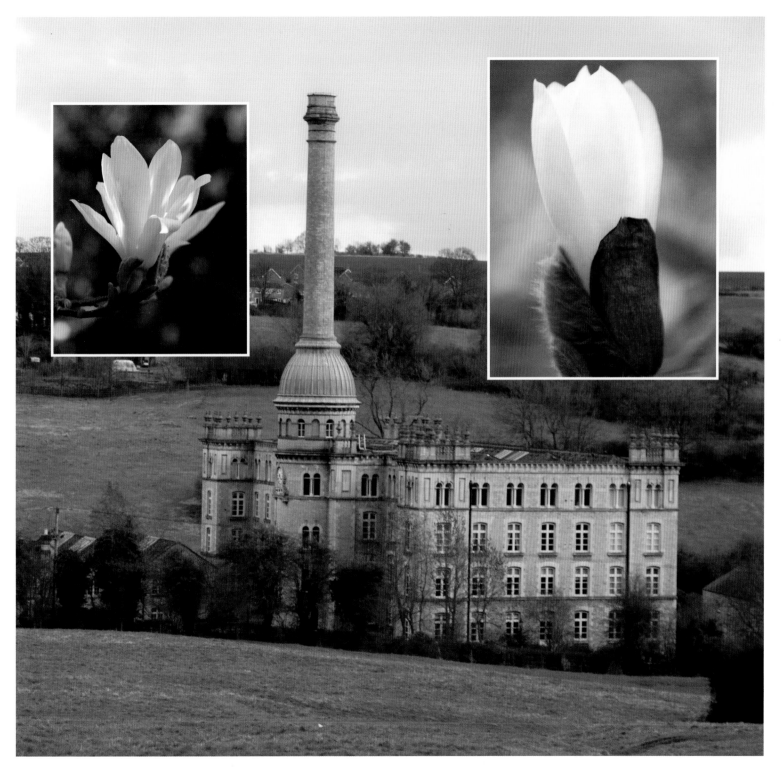

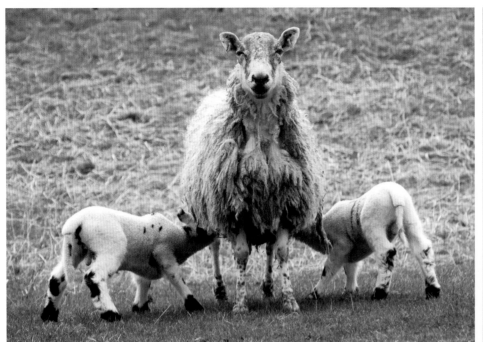
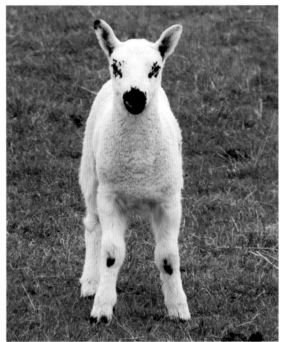
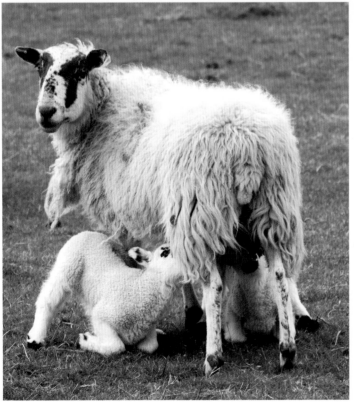
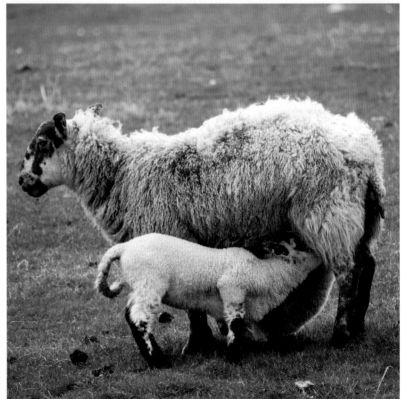

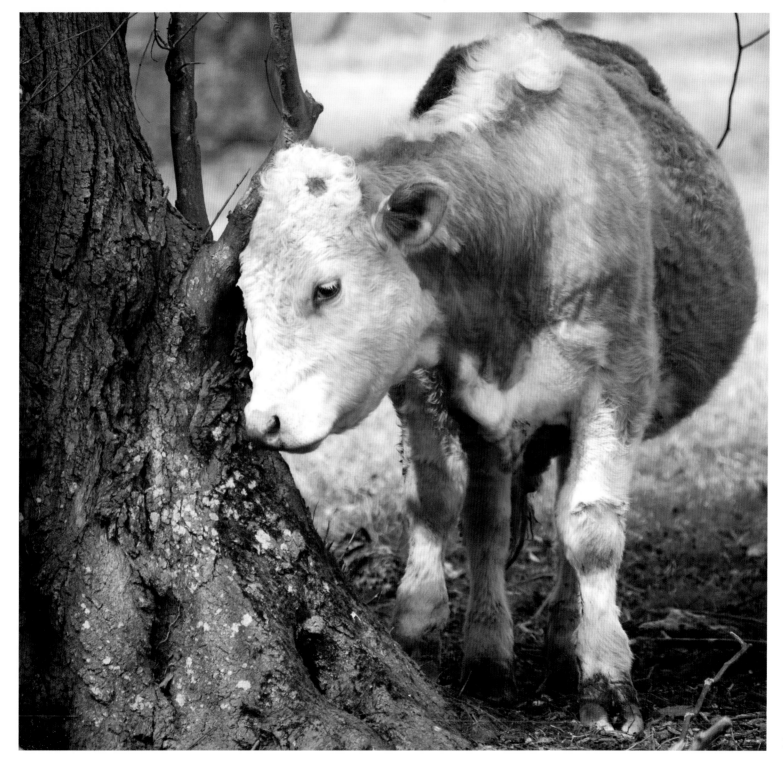

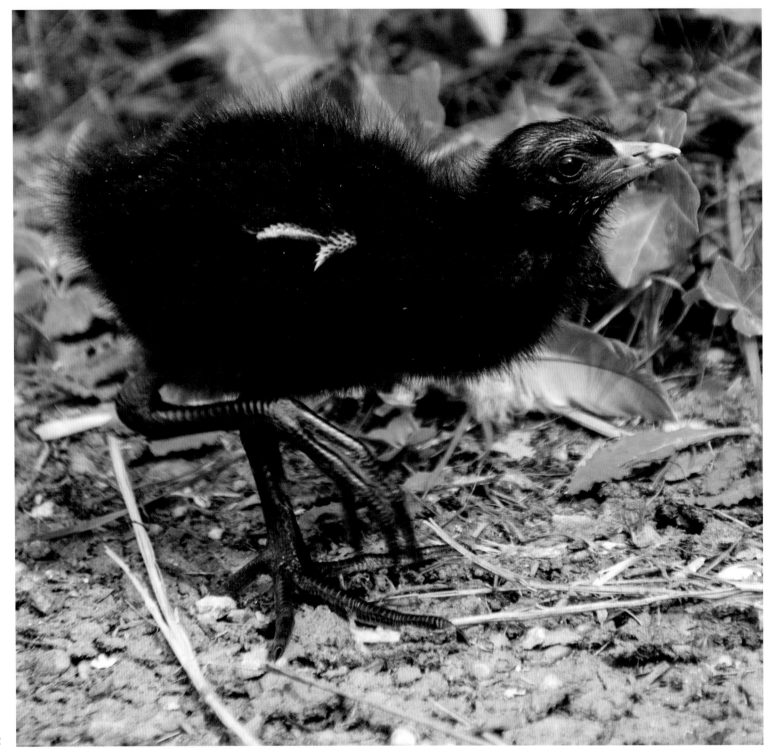

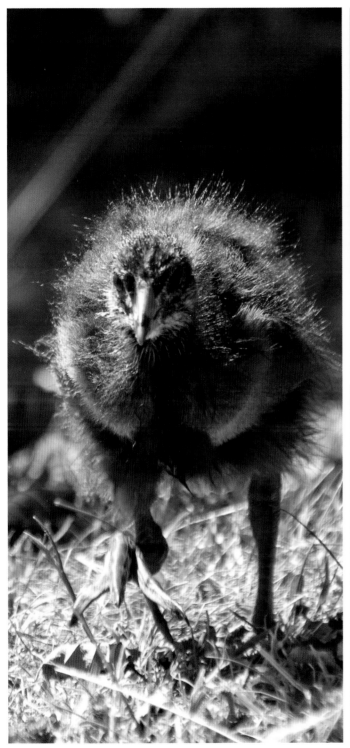
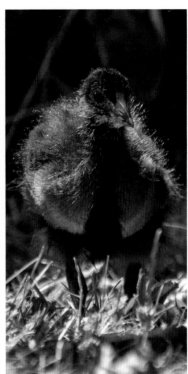
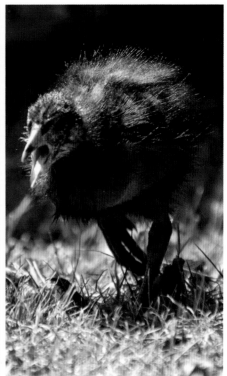
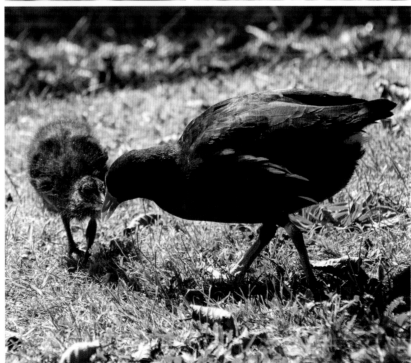

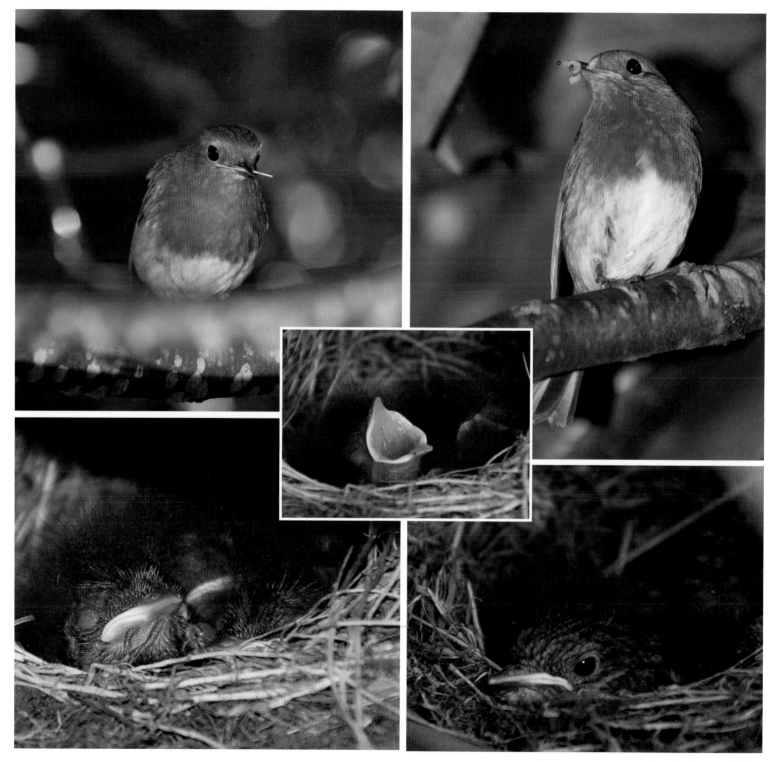

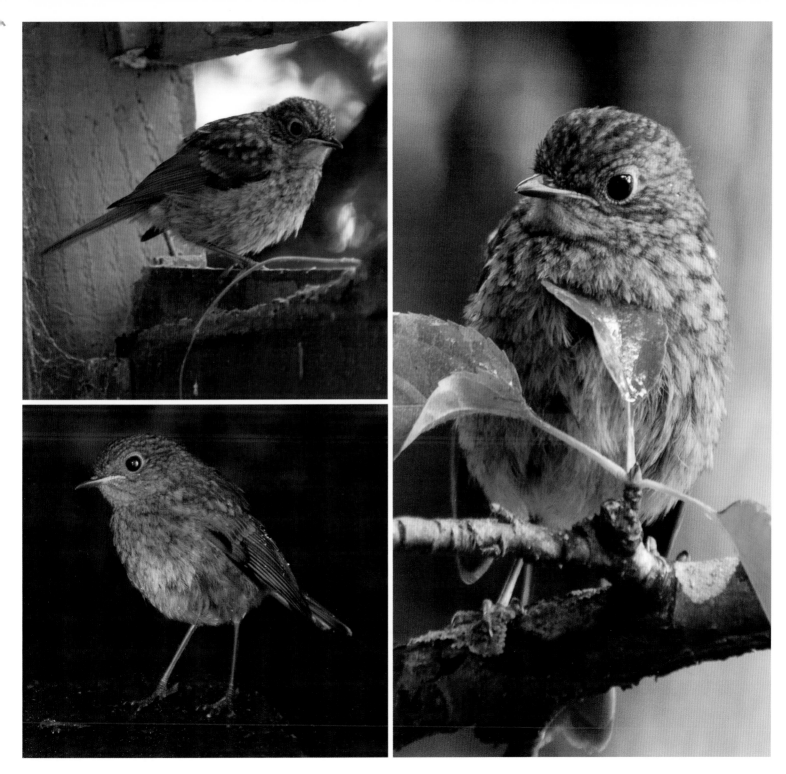

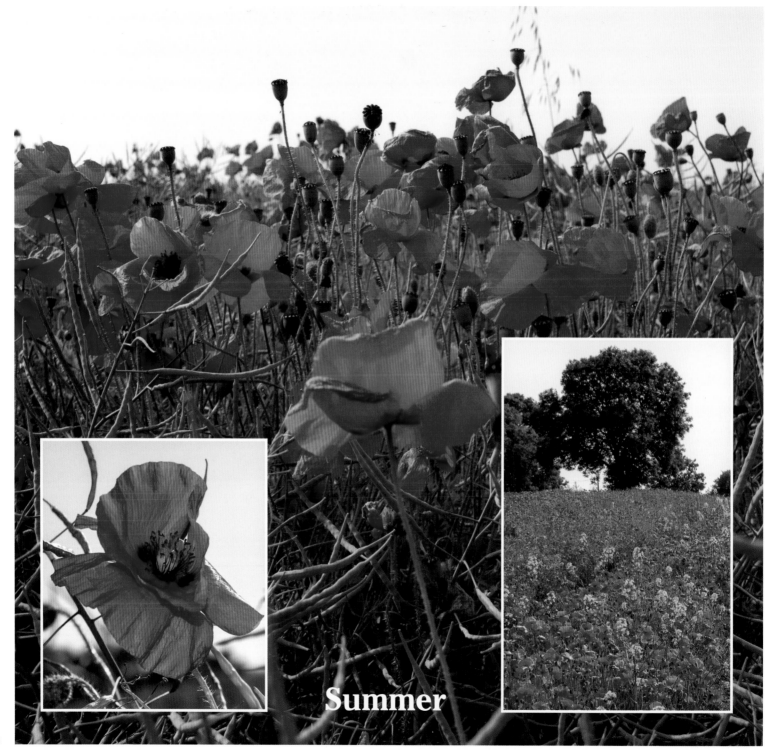

Summer

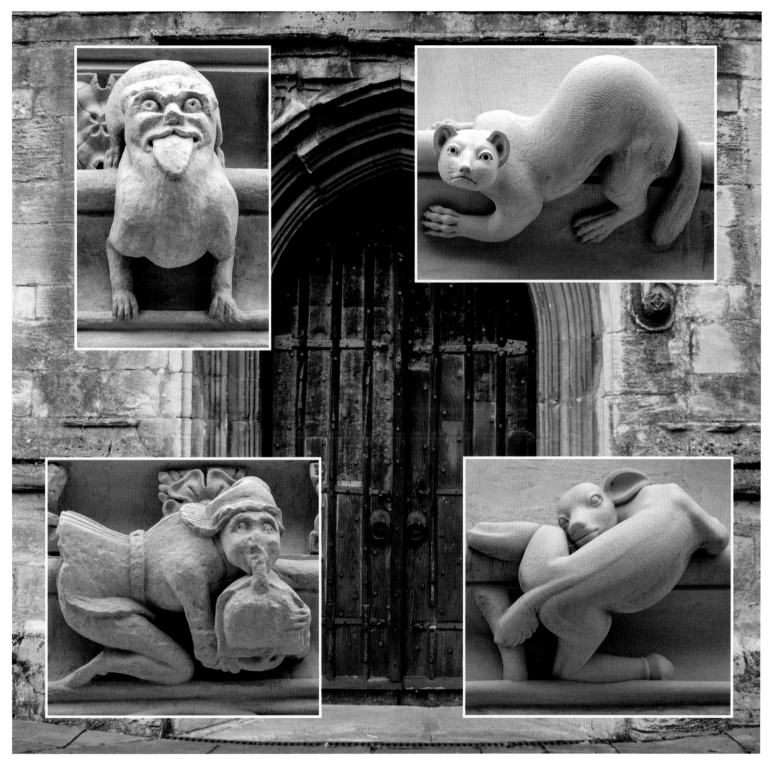

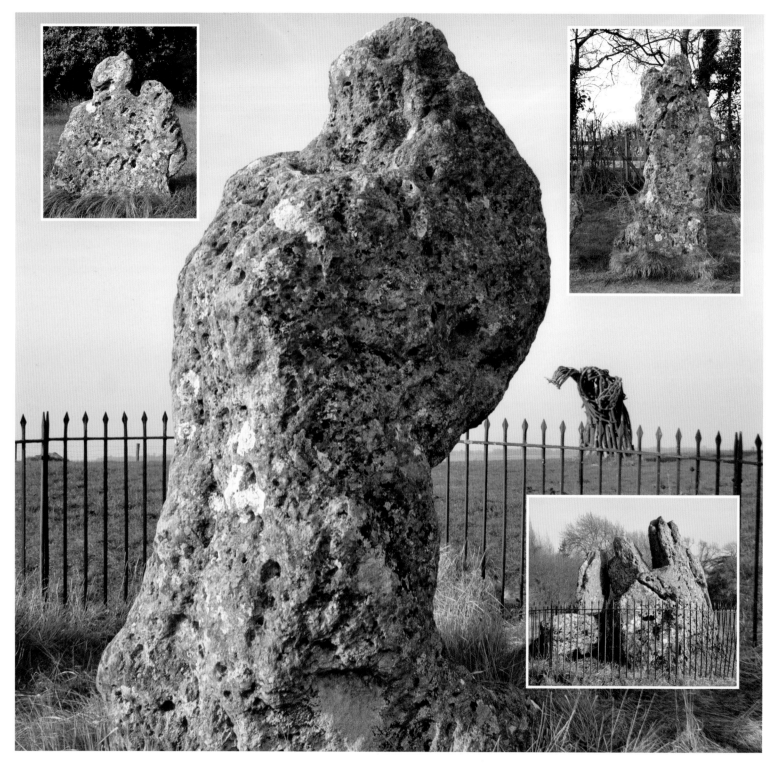

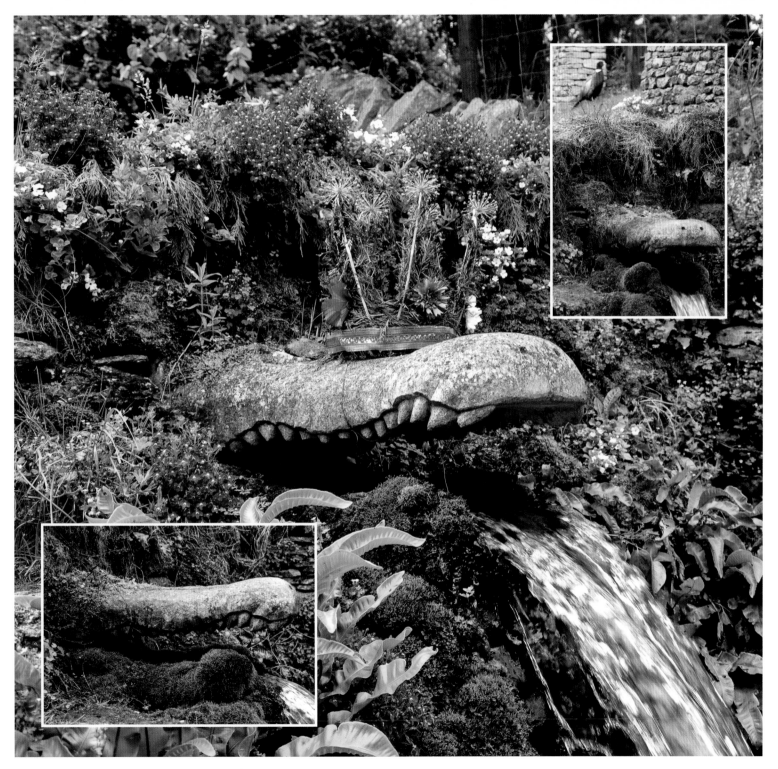

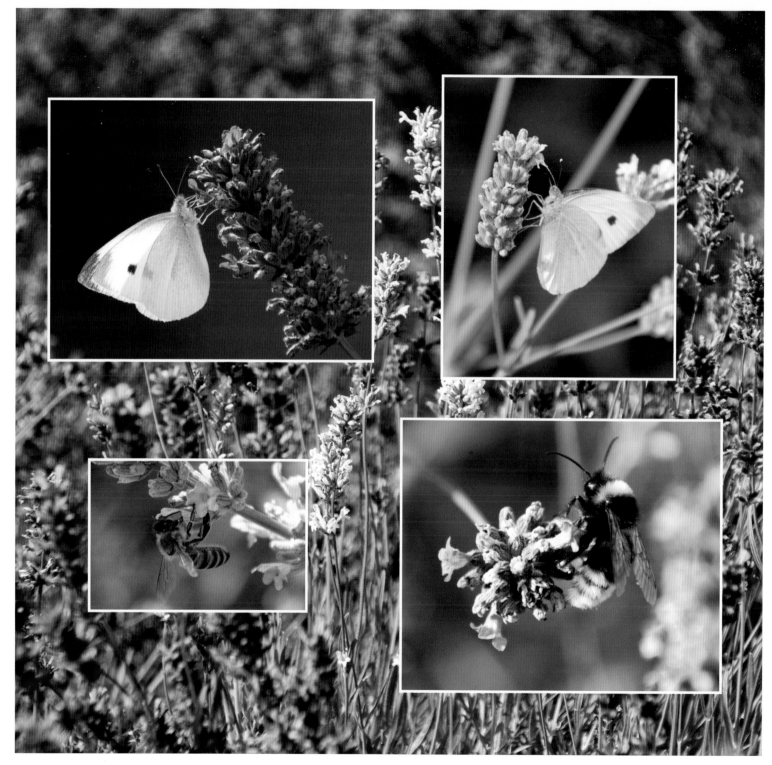

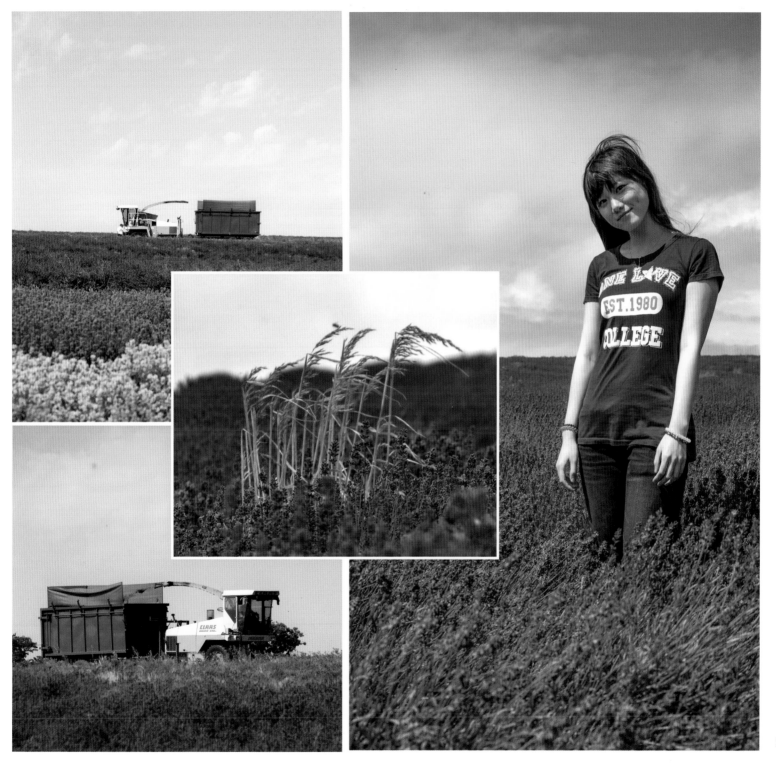

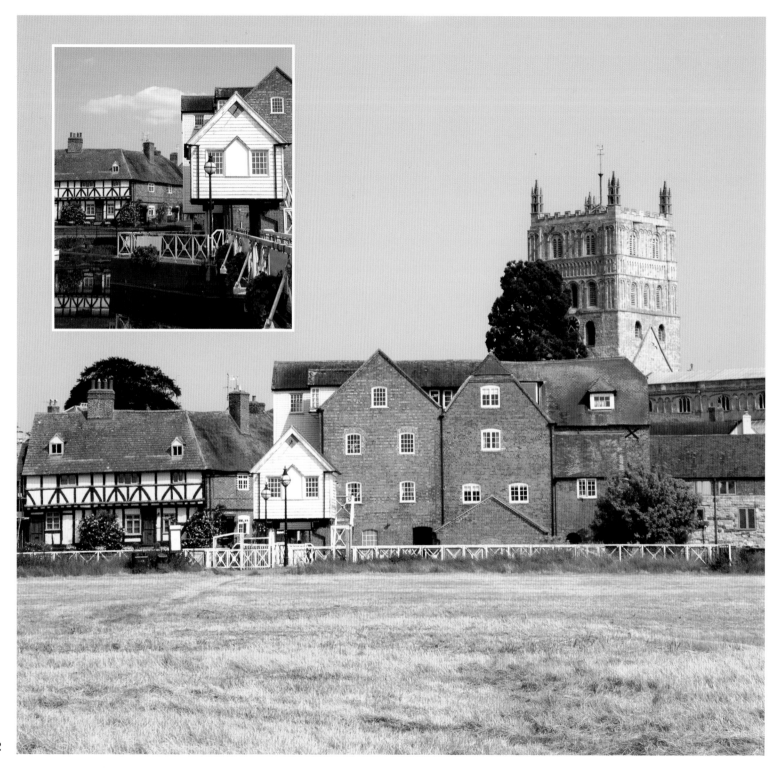

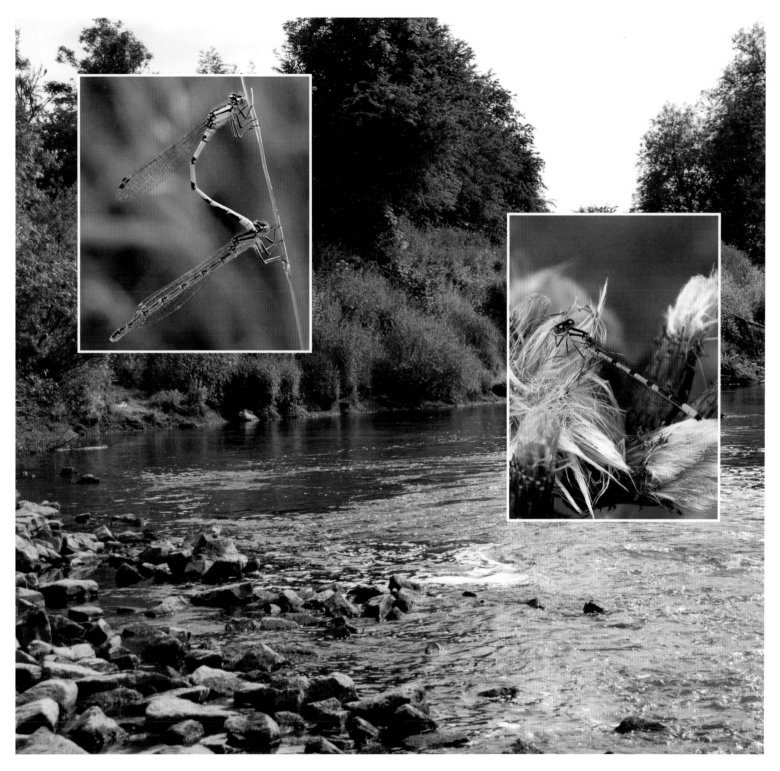

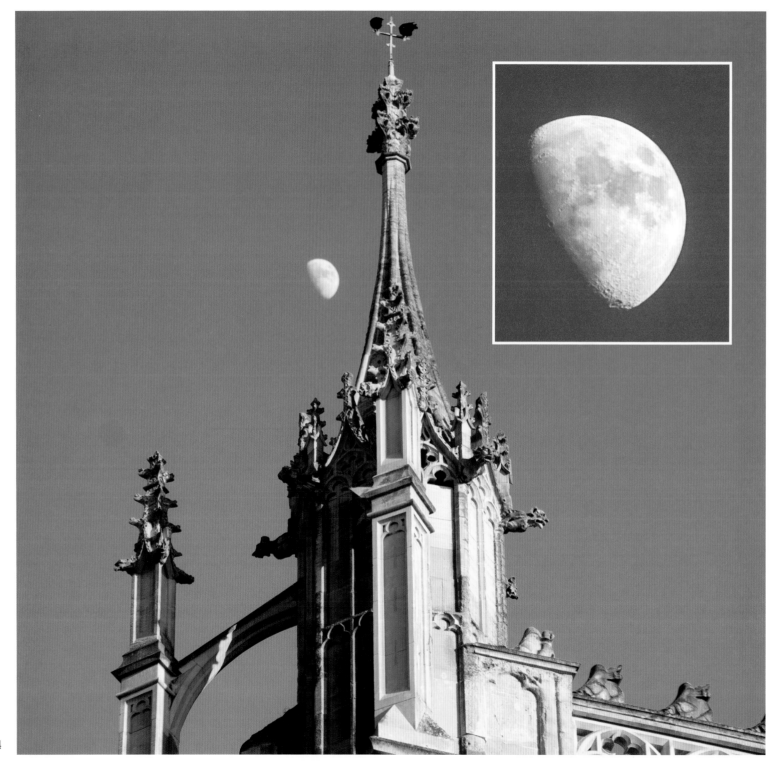

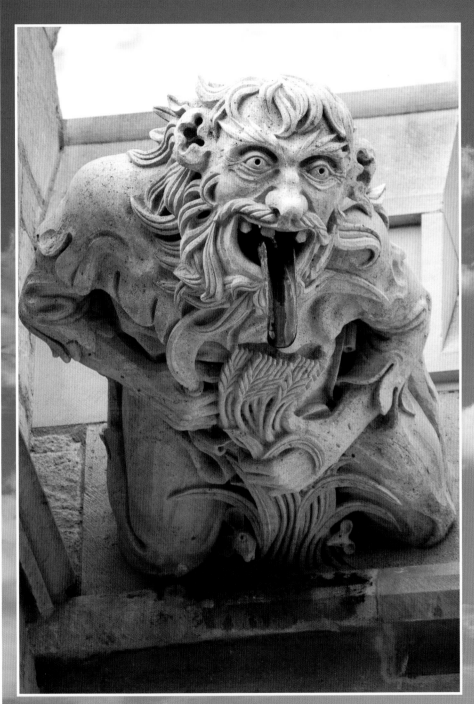

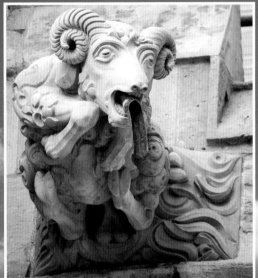

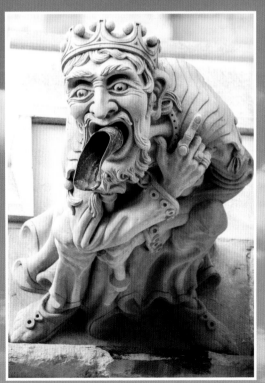

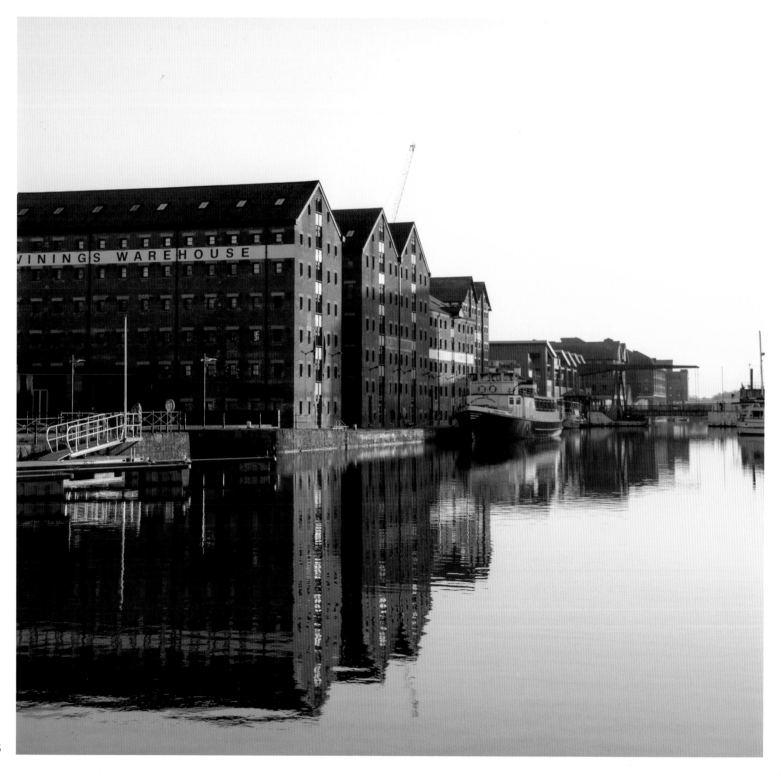

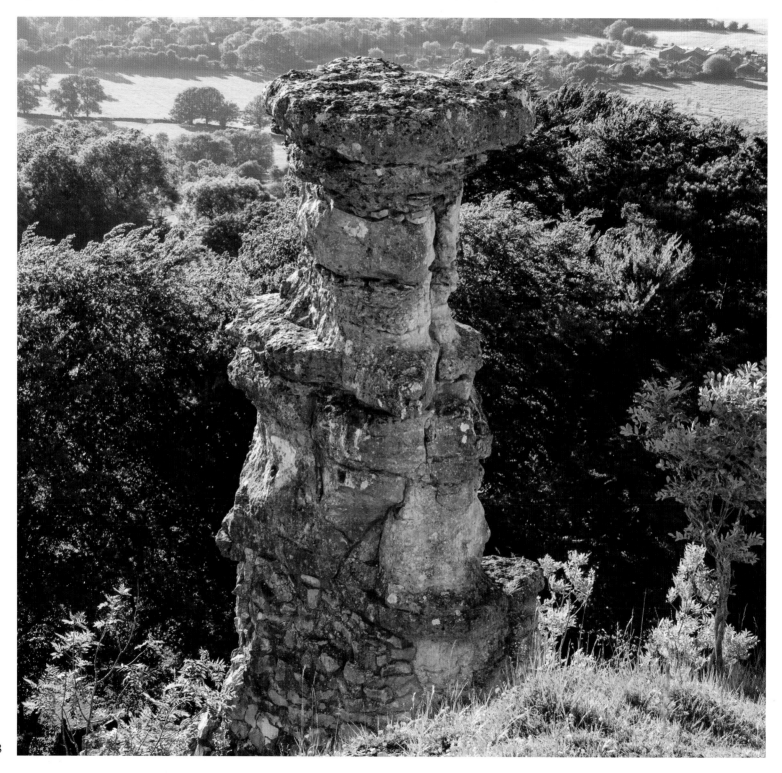

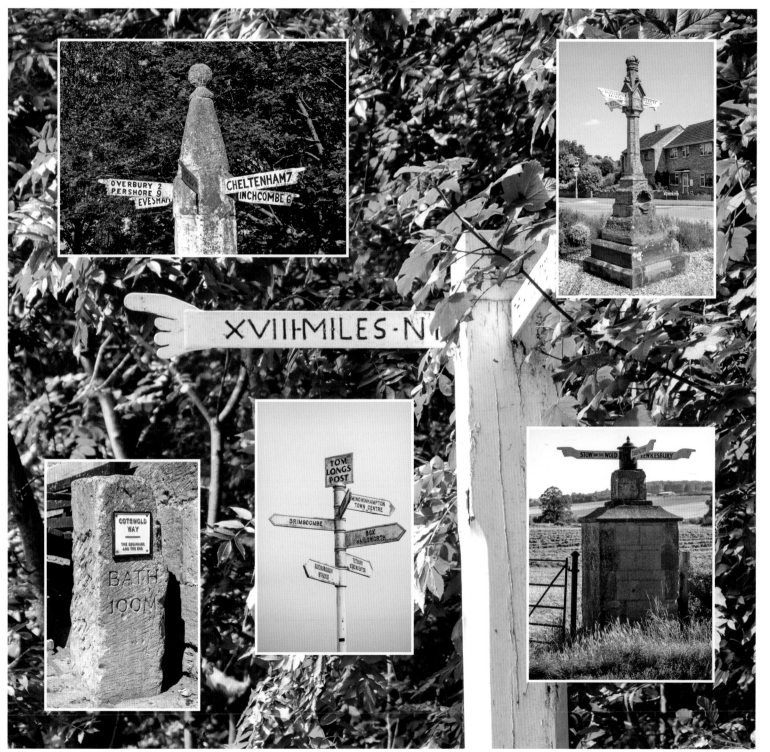

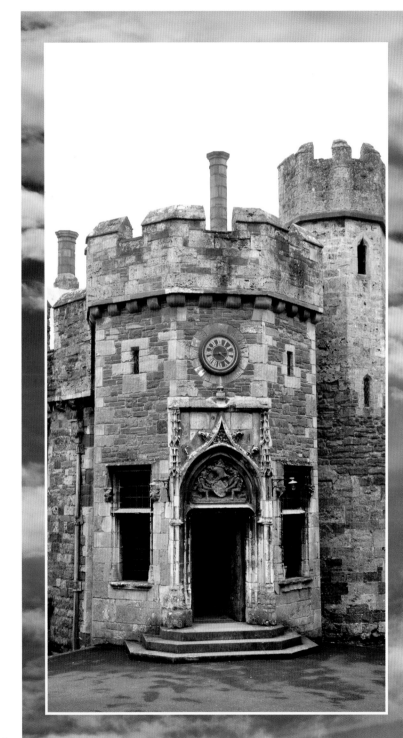

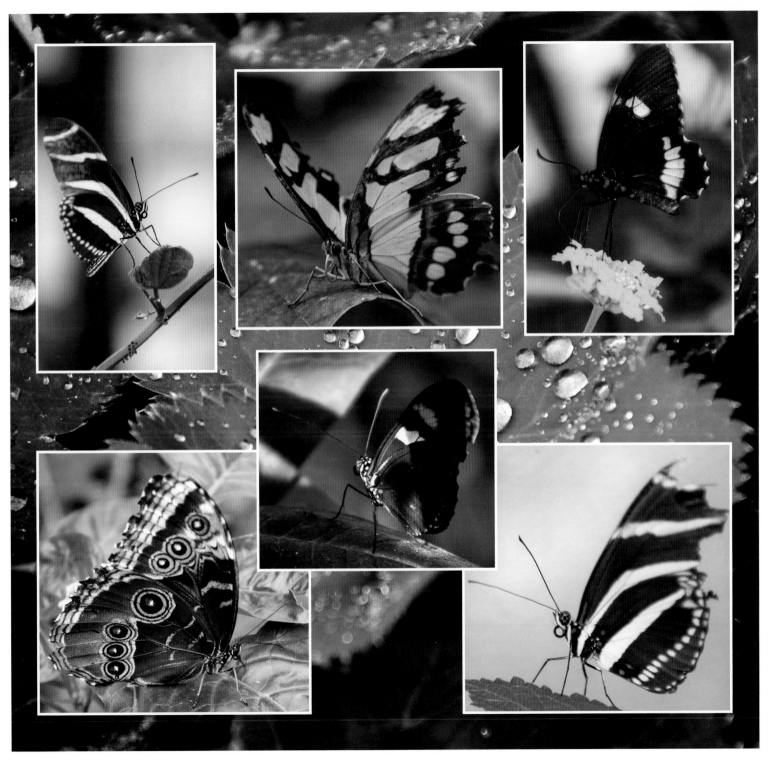

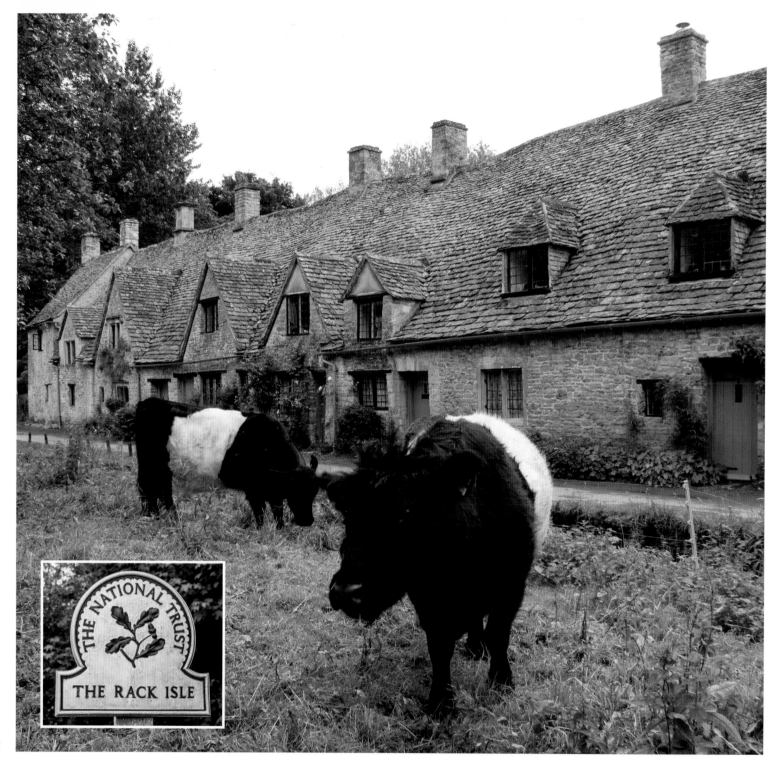

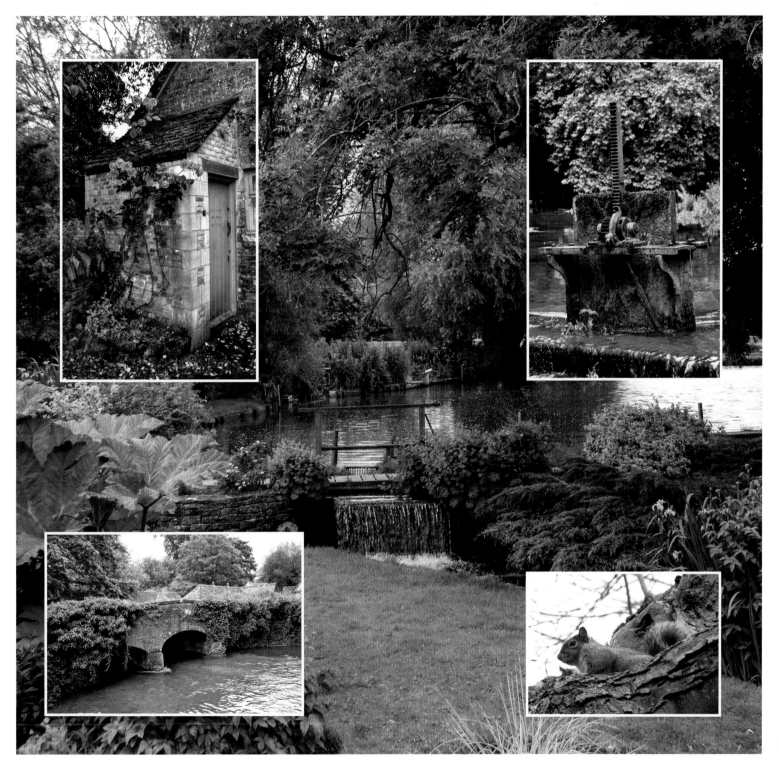

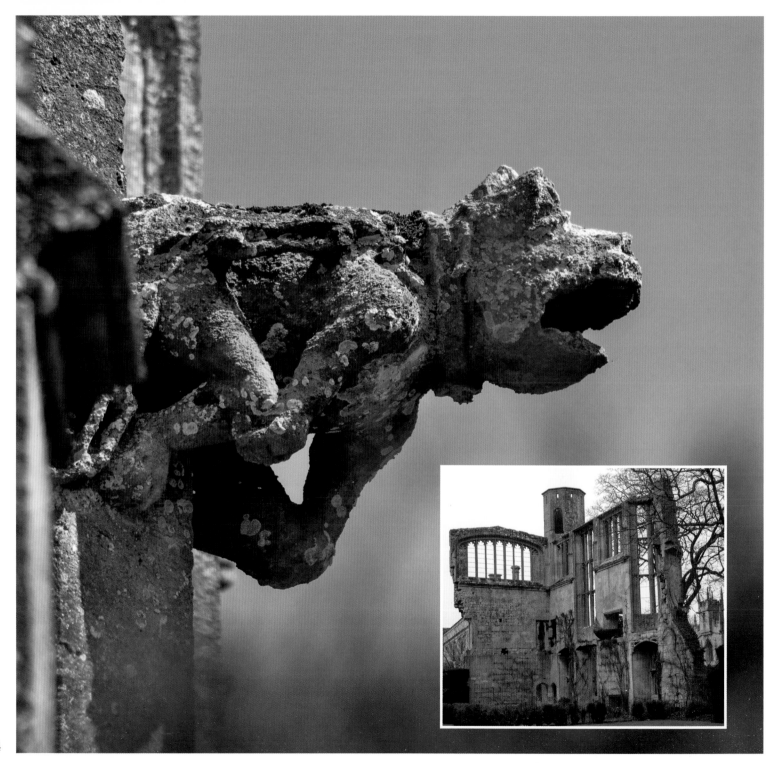

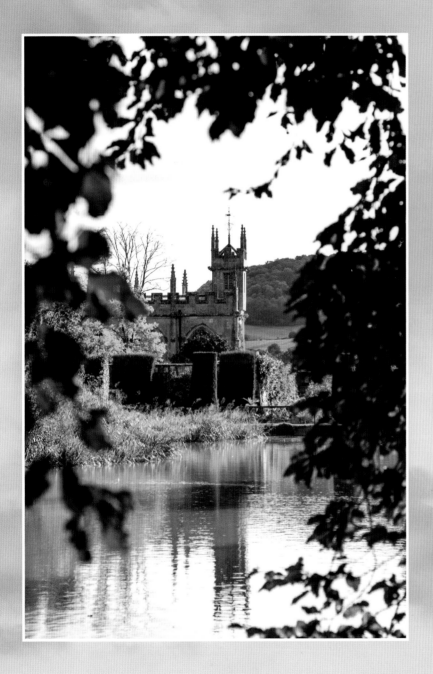

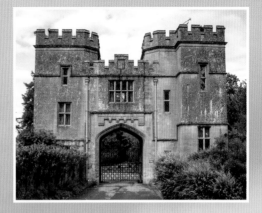

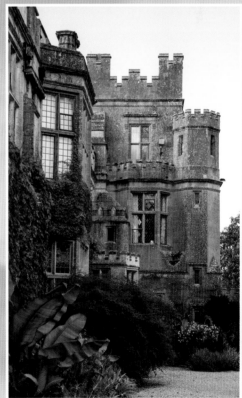

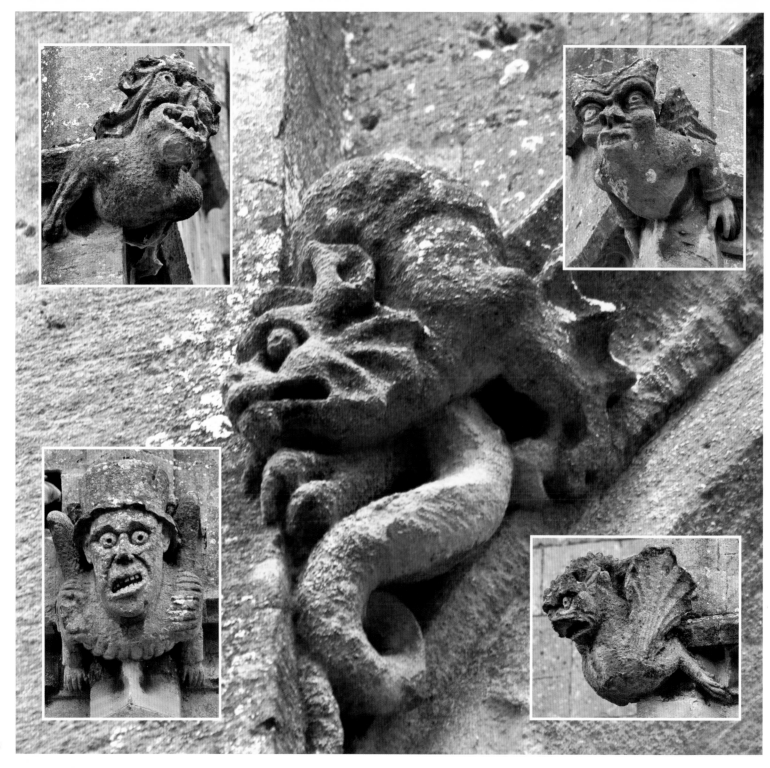

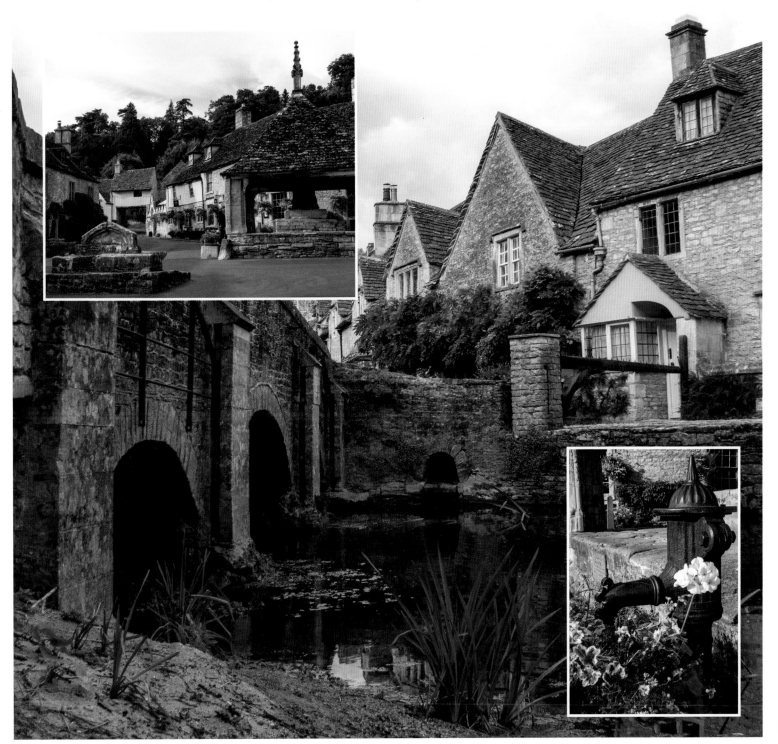

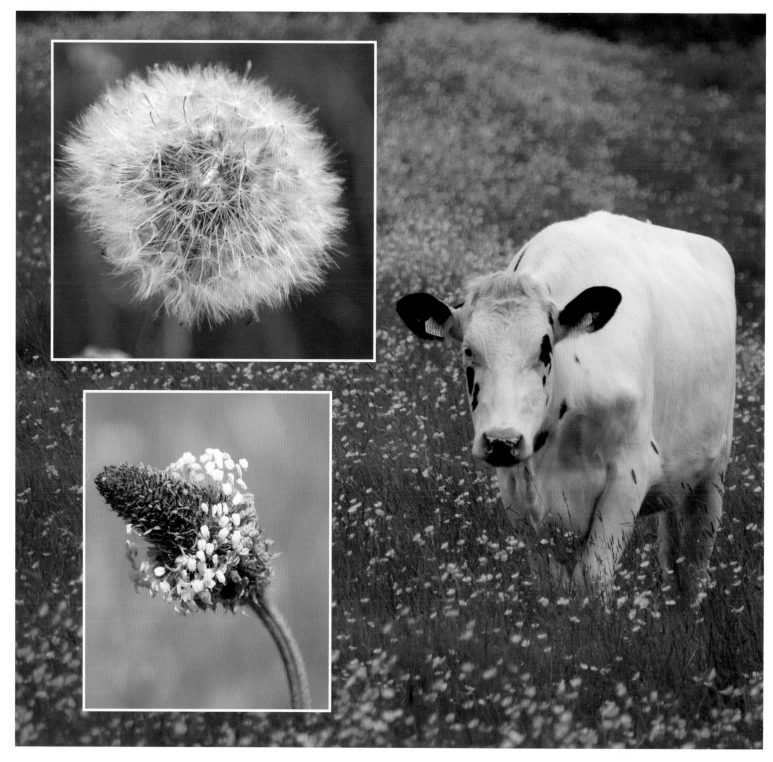

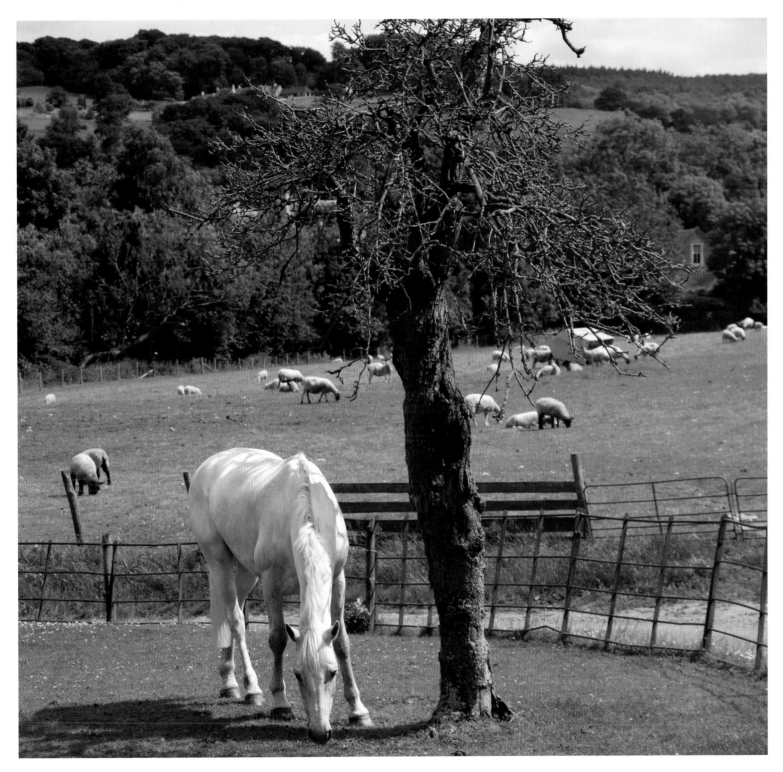

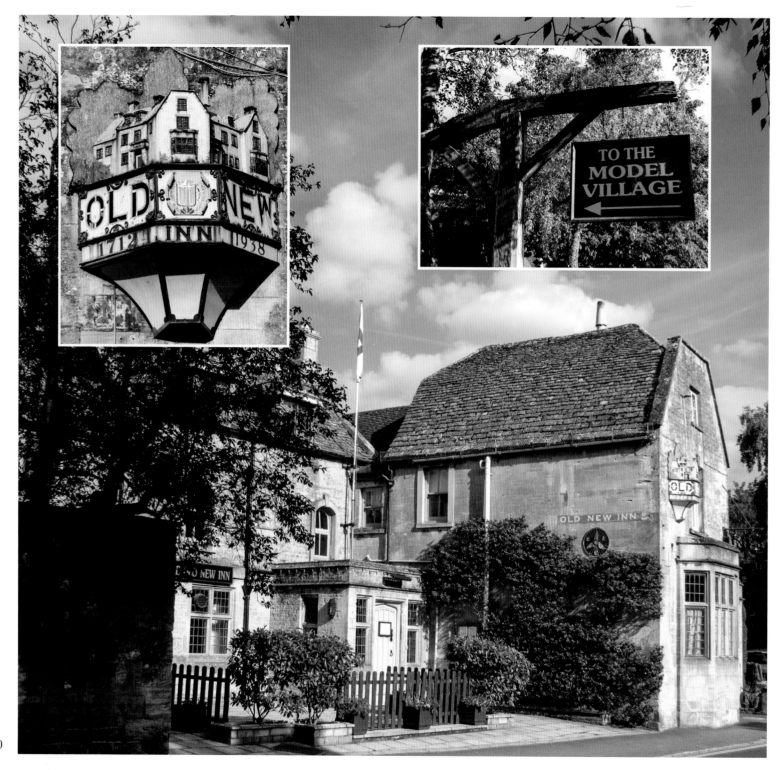

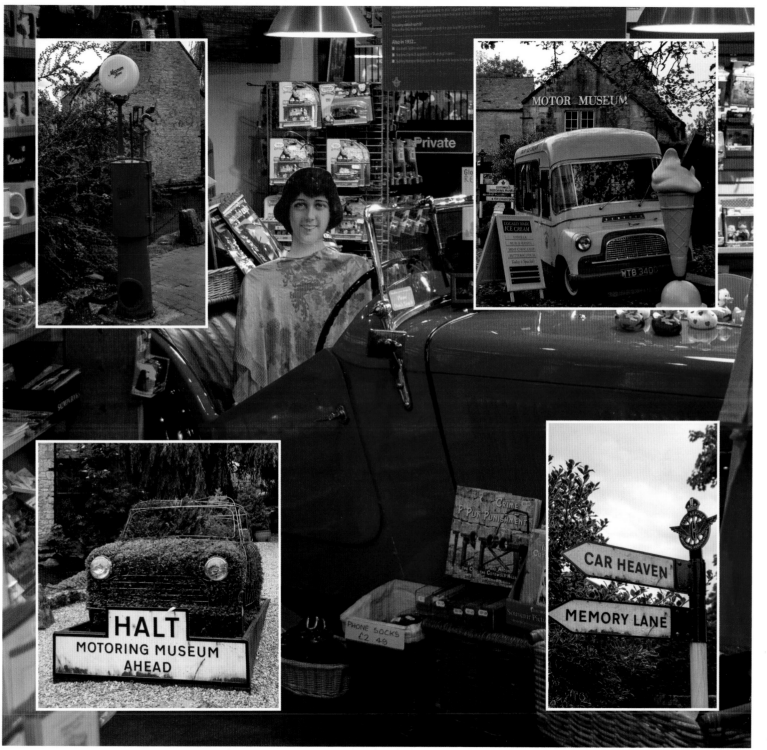

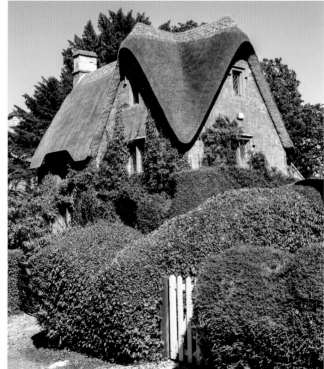

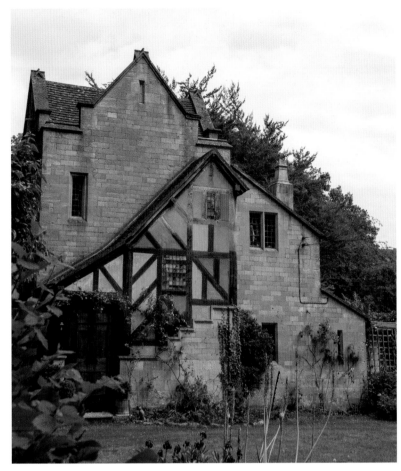

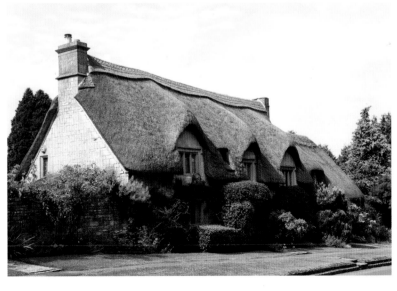

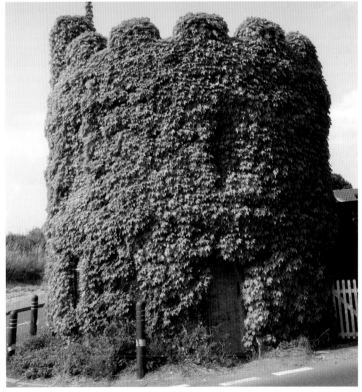

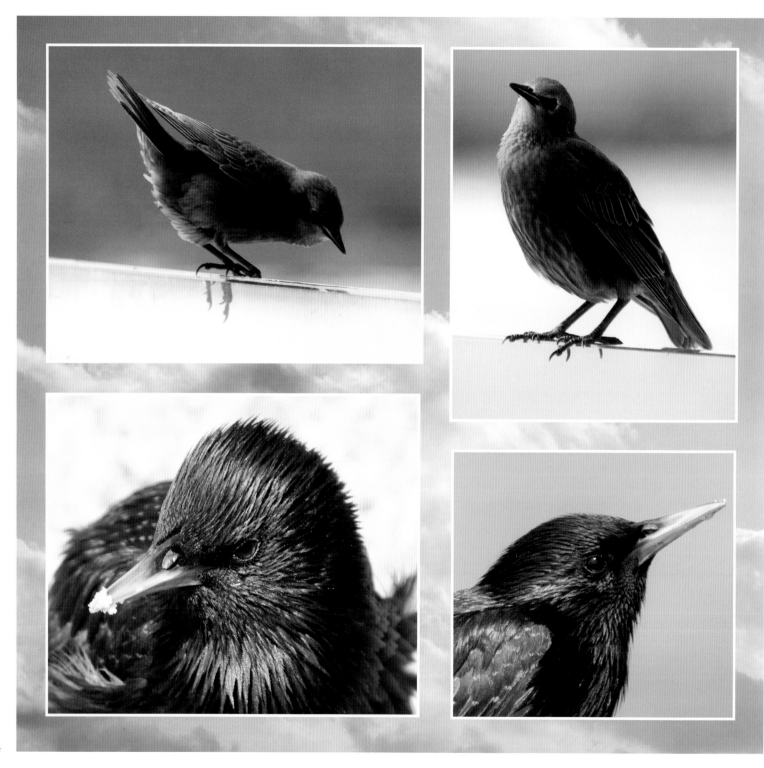

Autumn & Fall

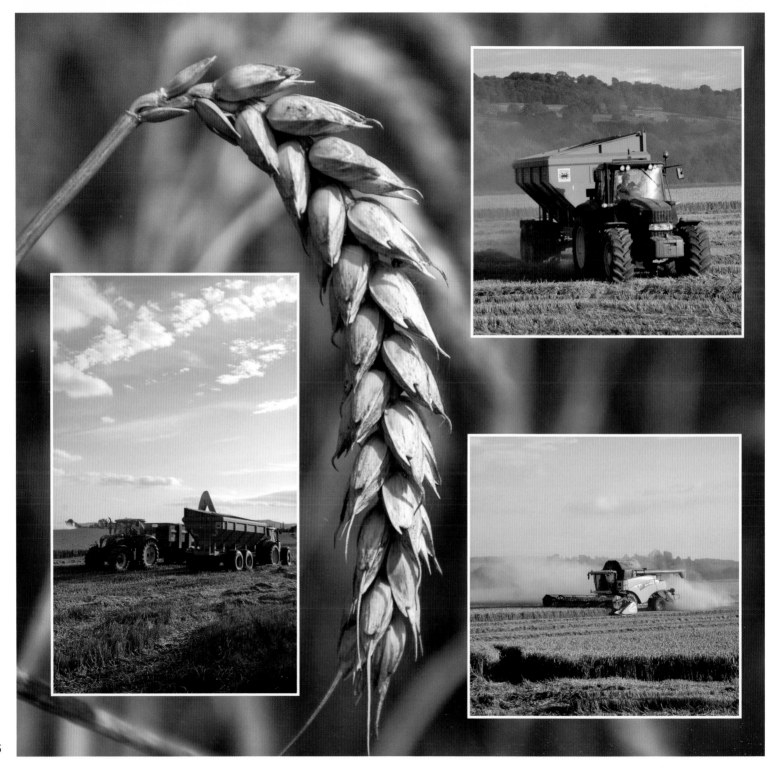

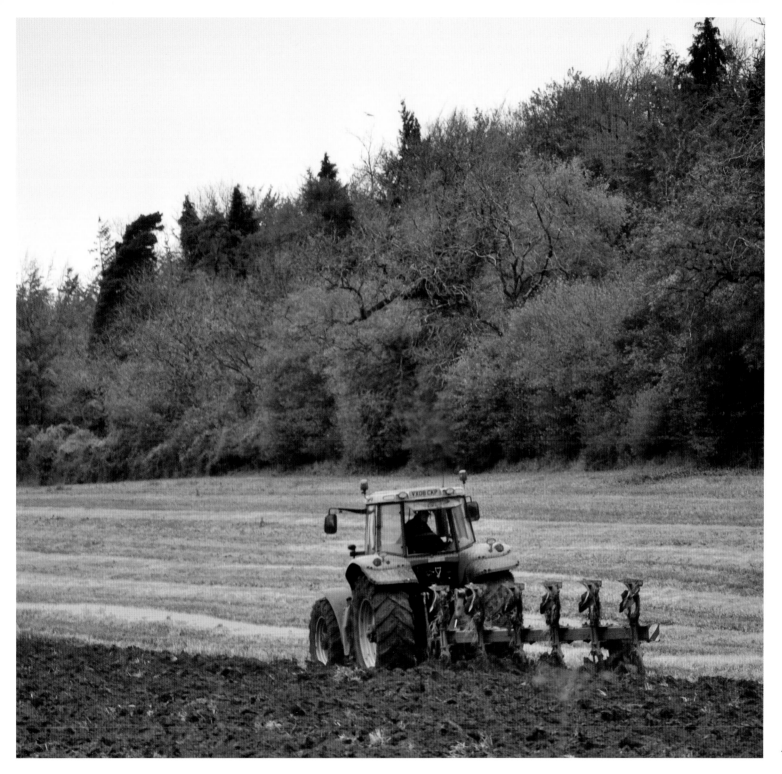

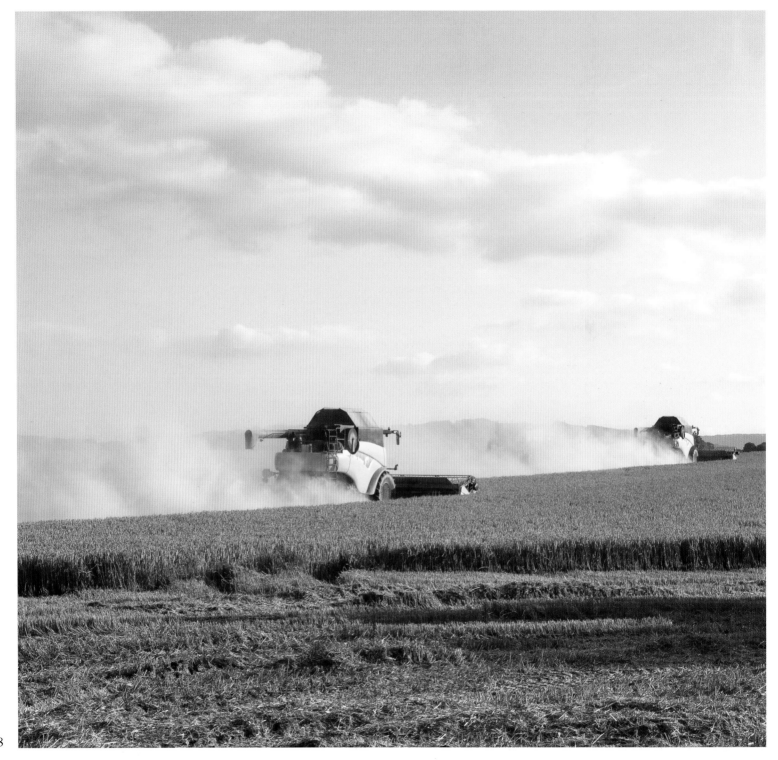

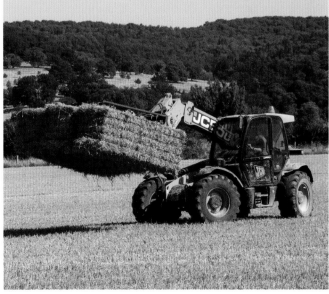

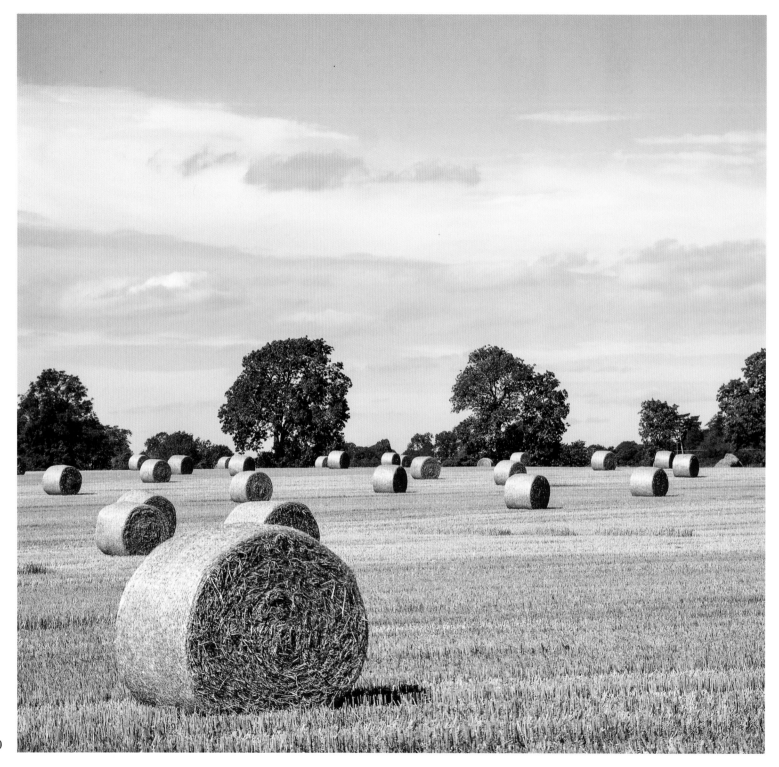

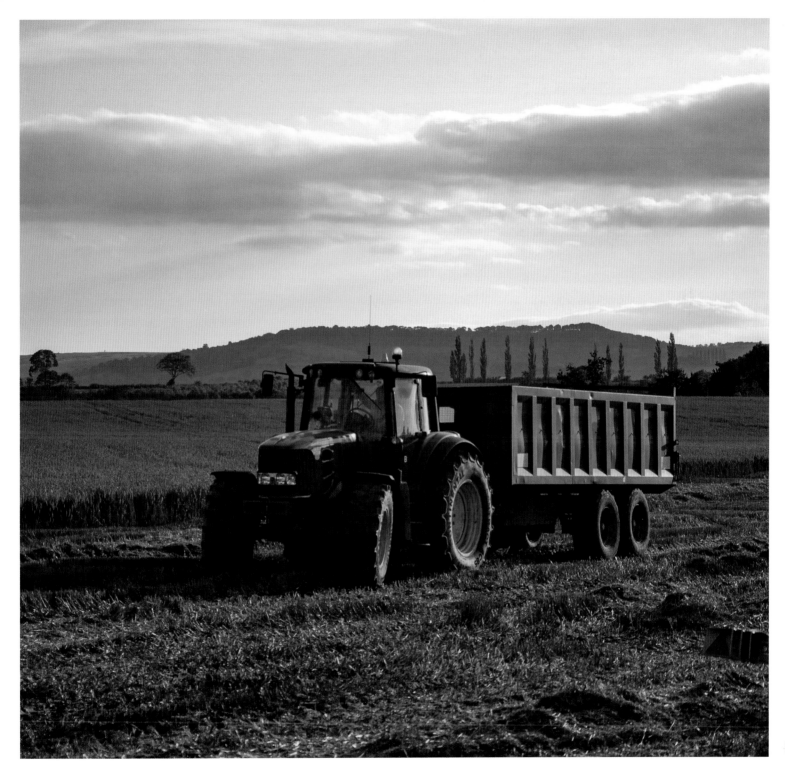

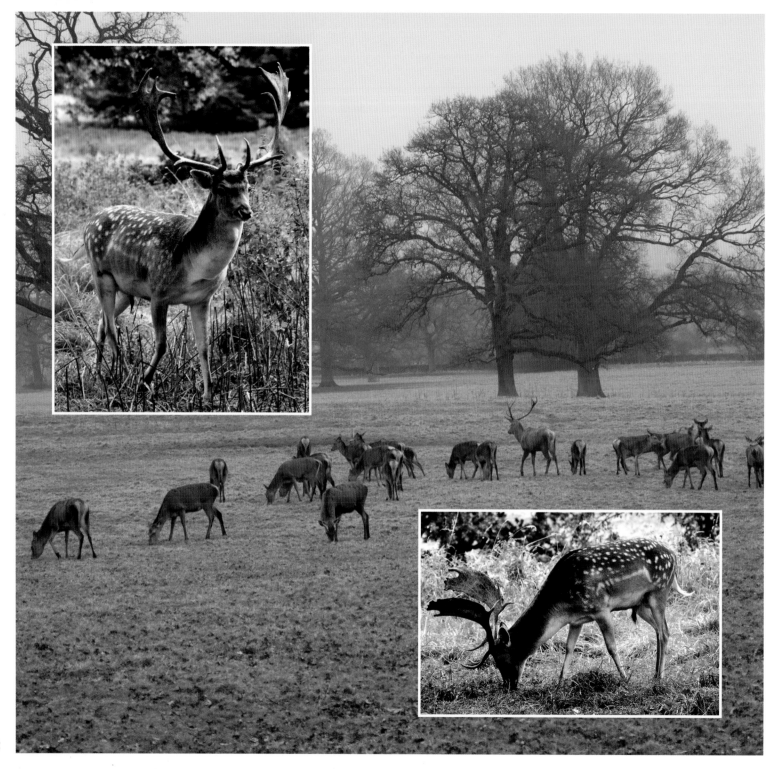

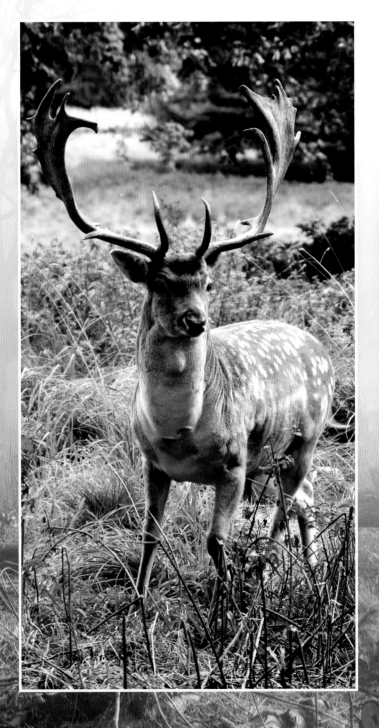

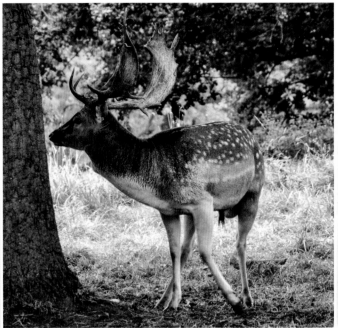

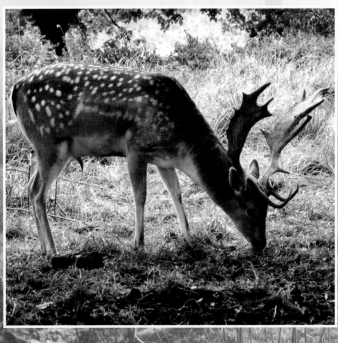

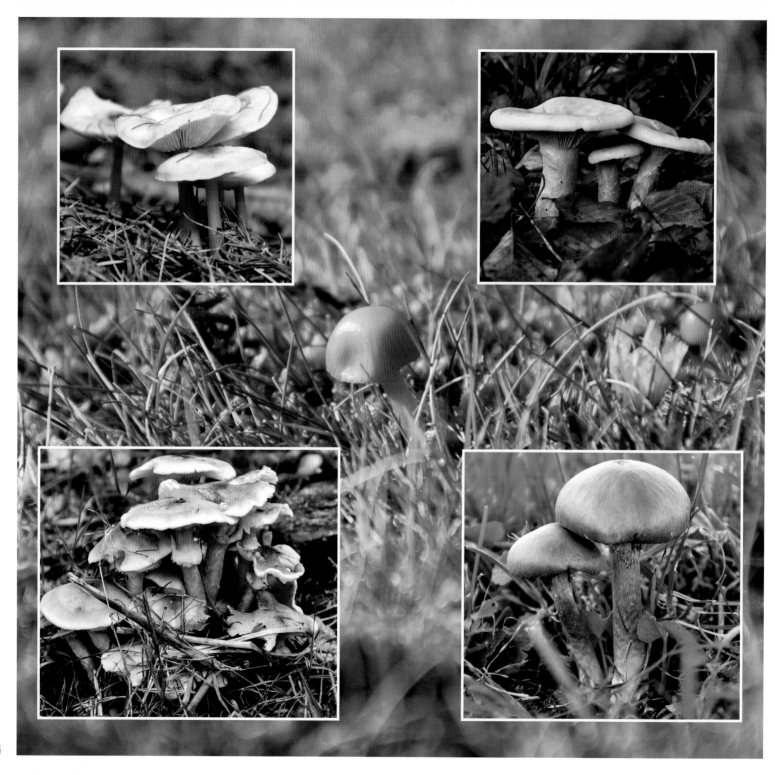

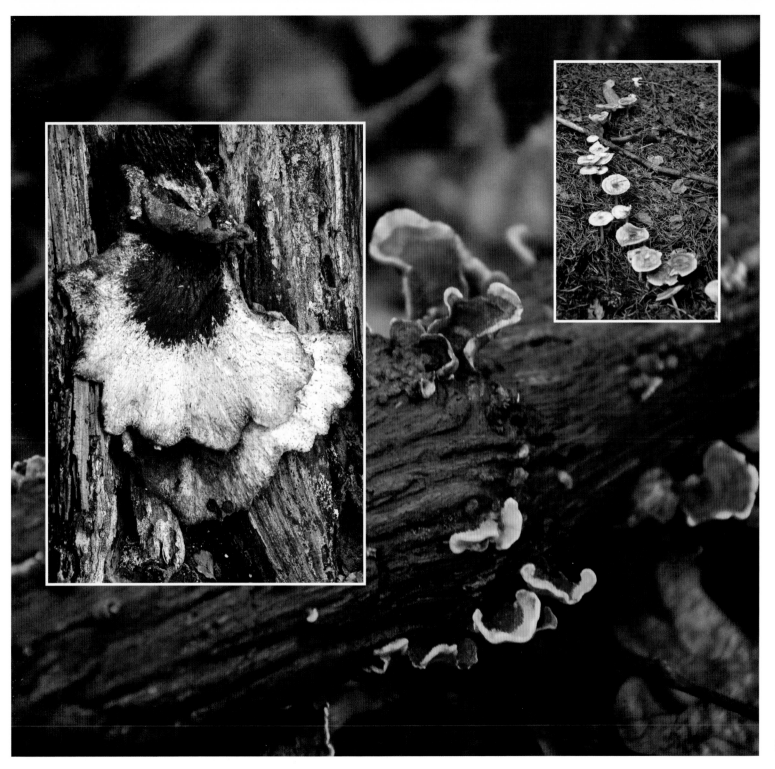

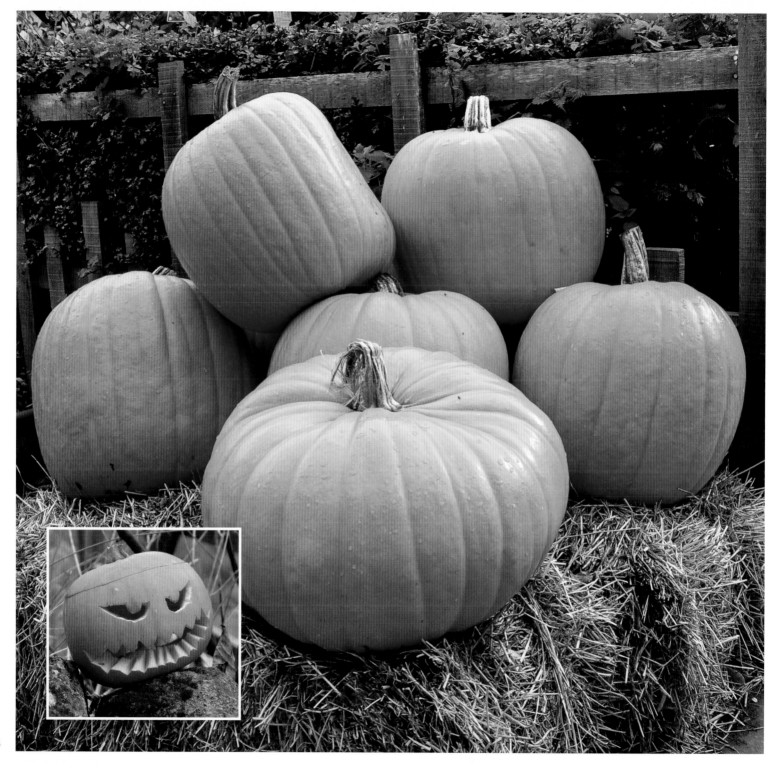

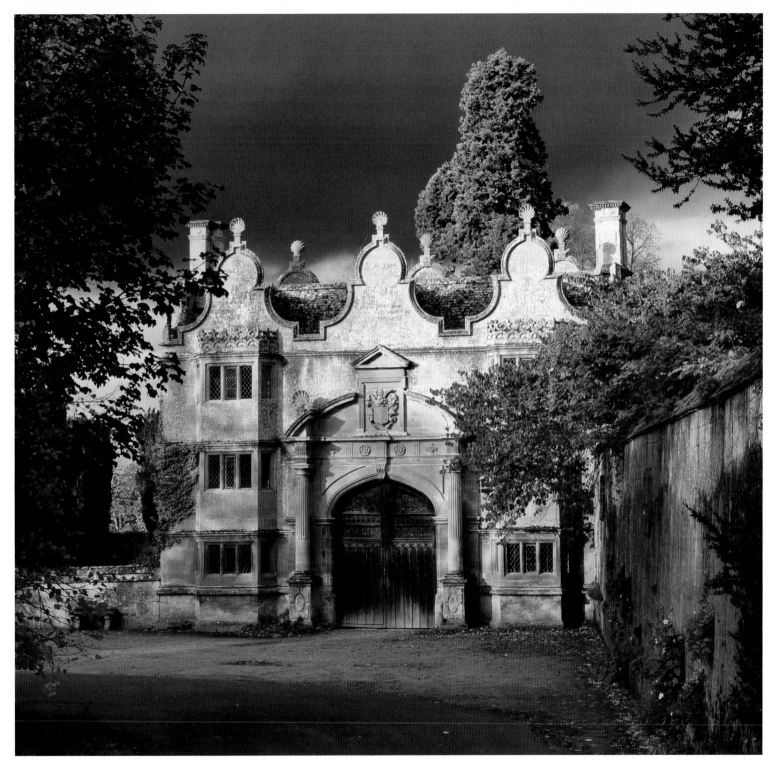

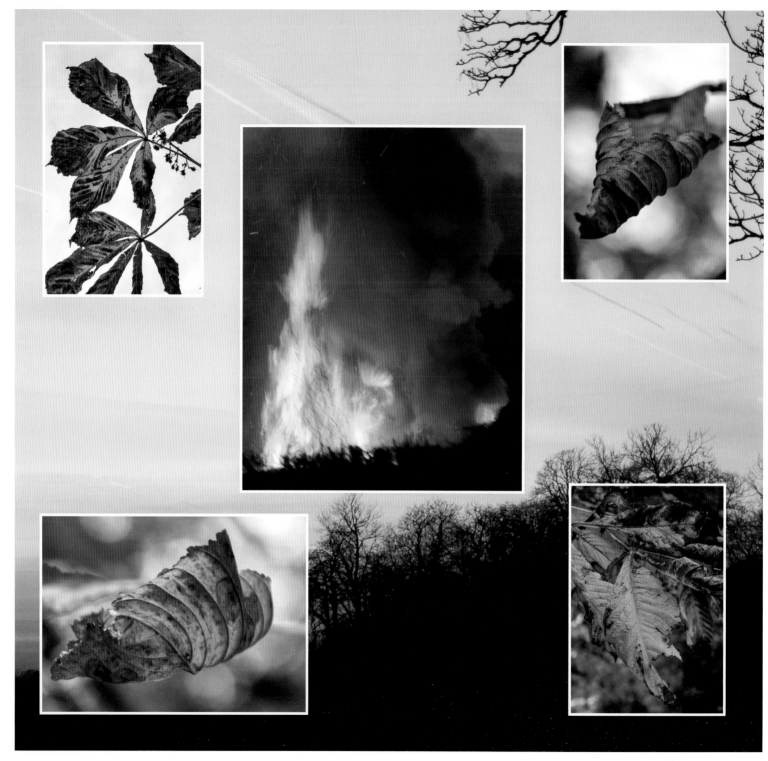

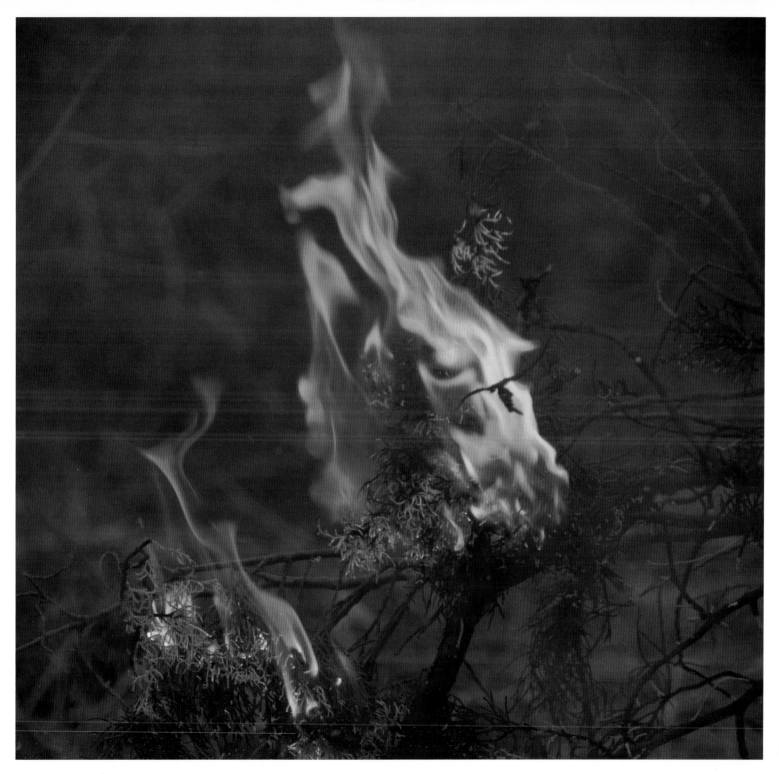

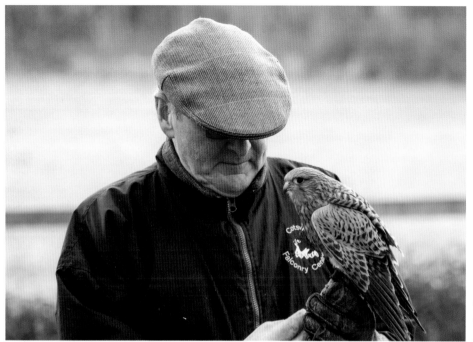

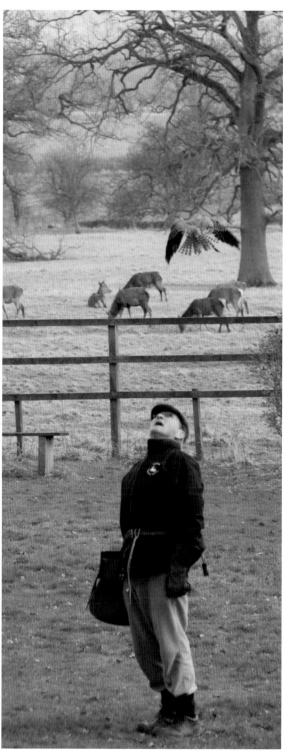

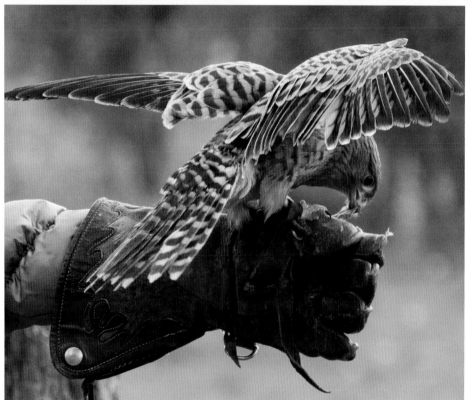

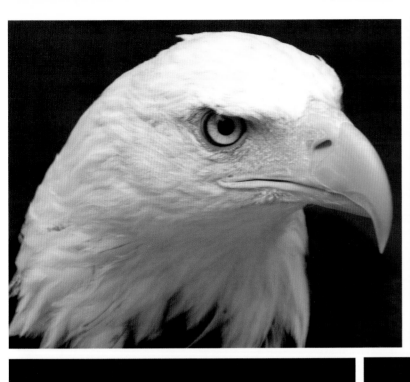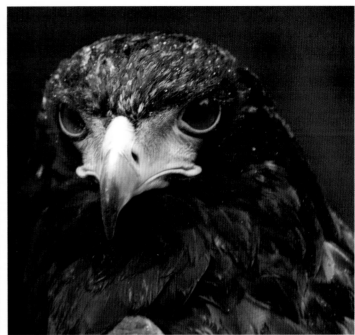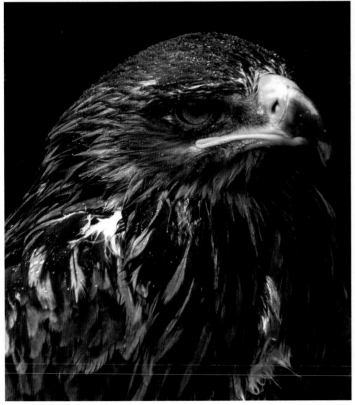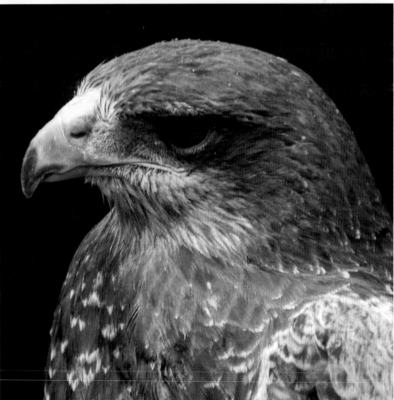

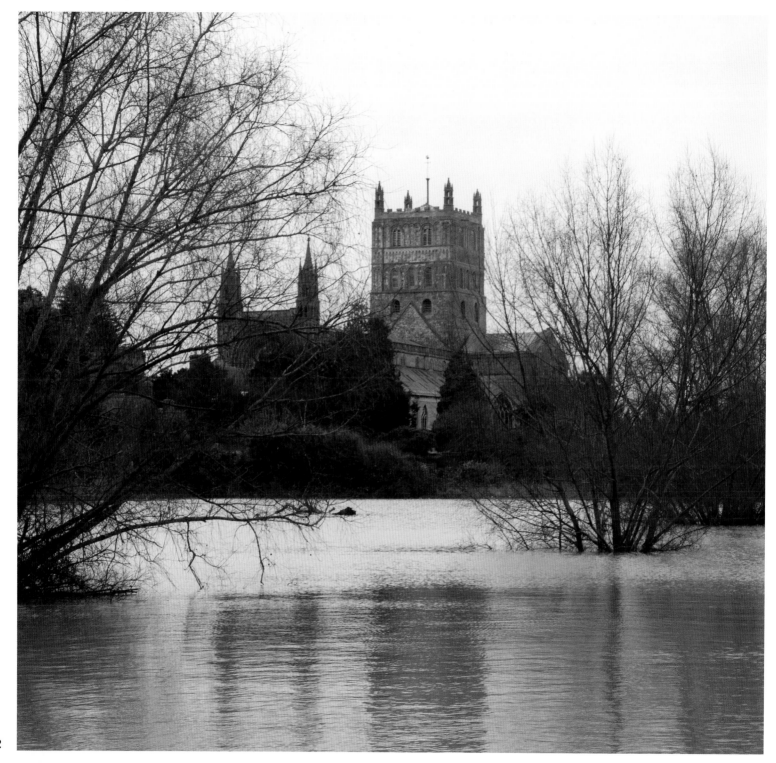

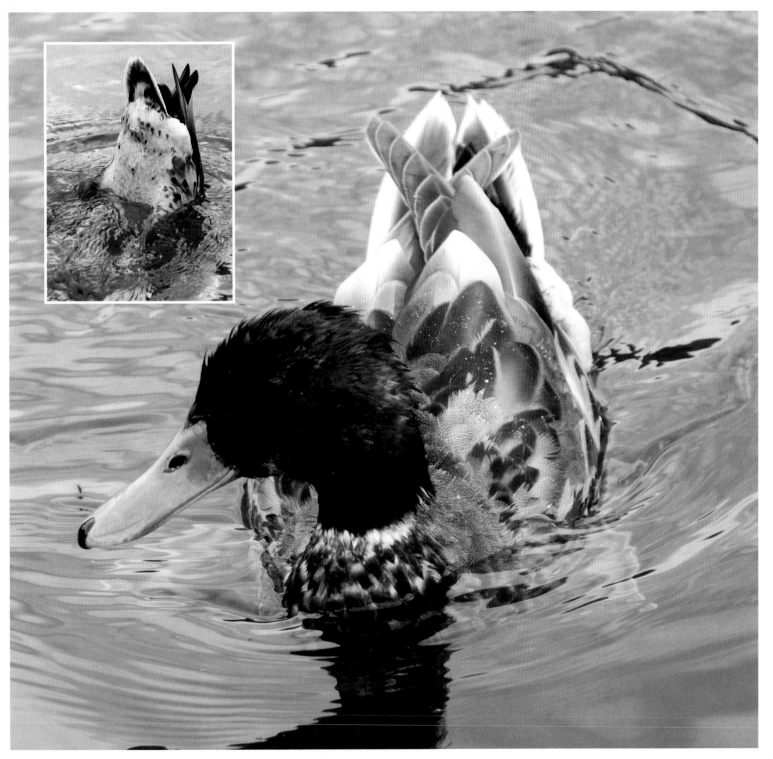

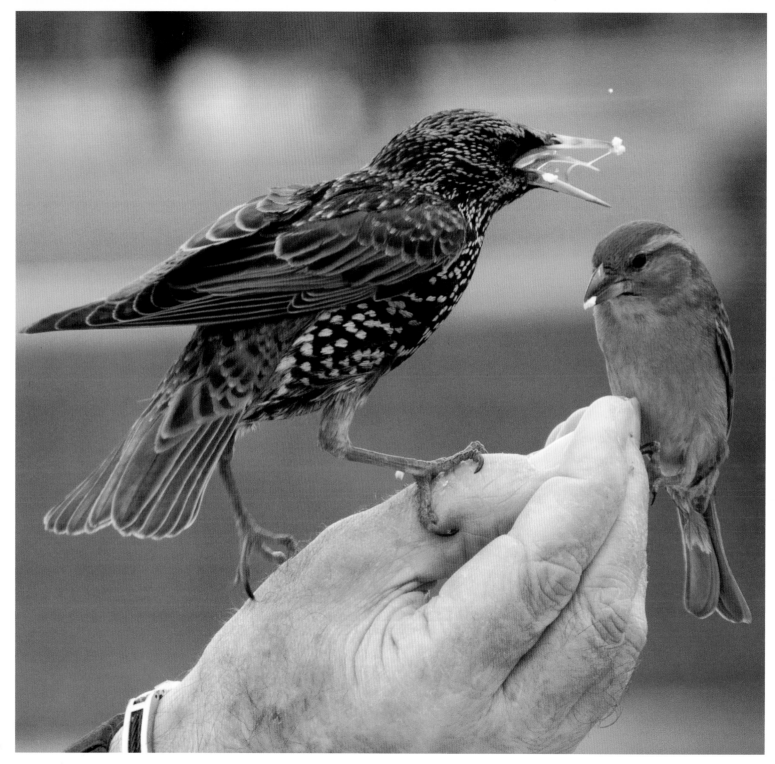

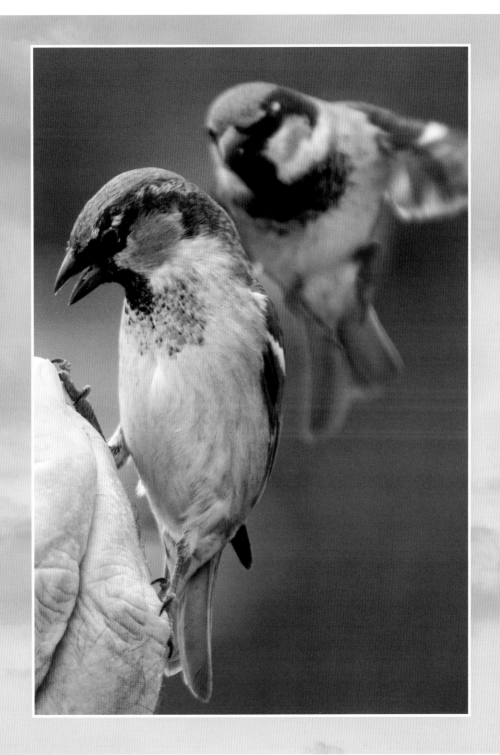

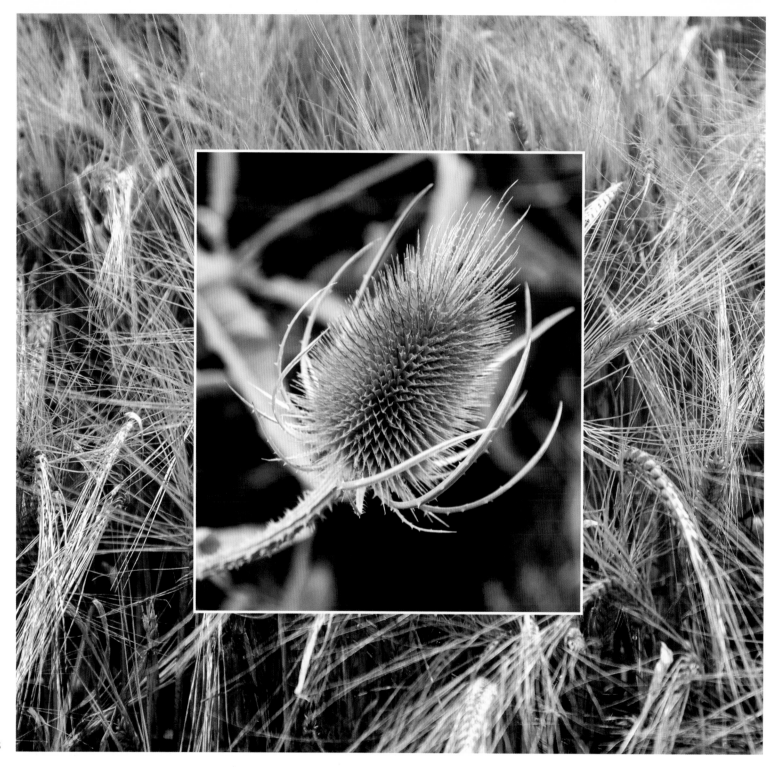

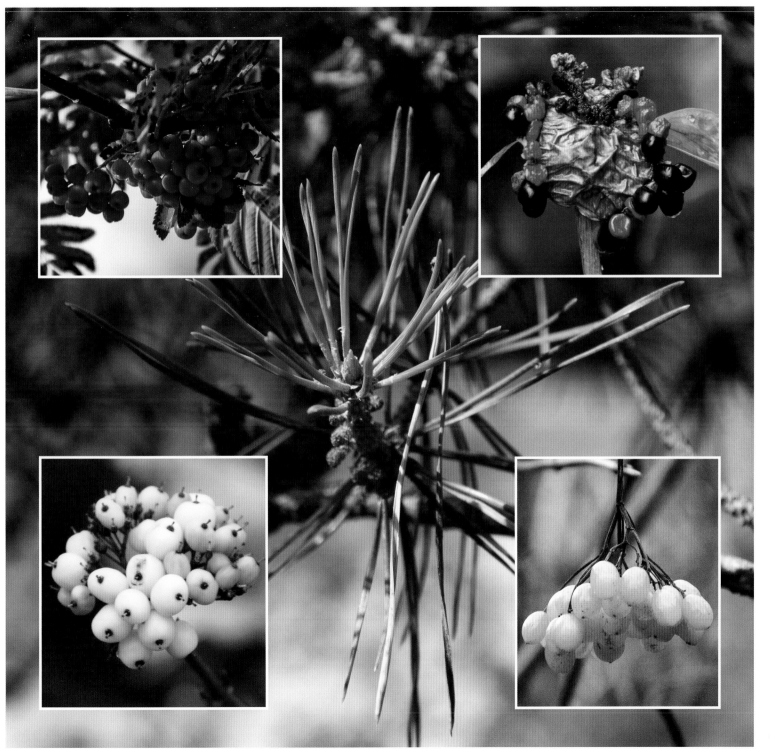

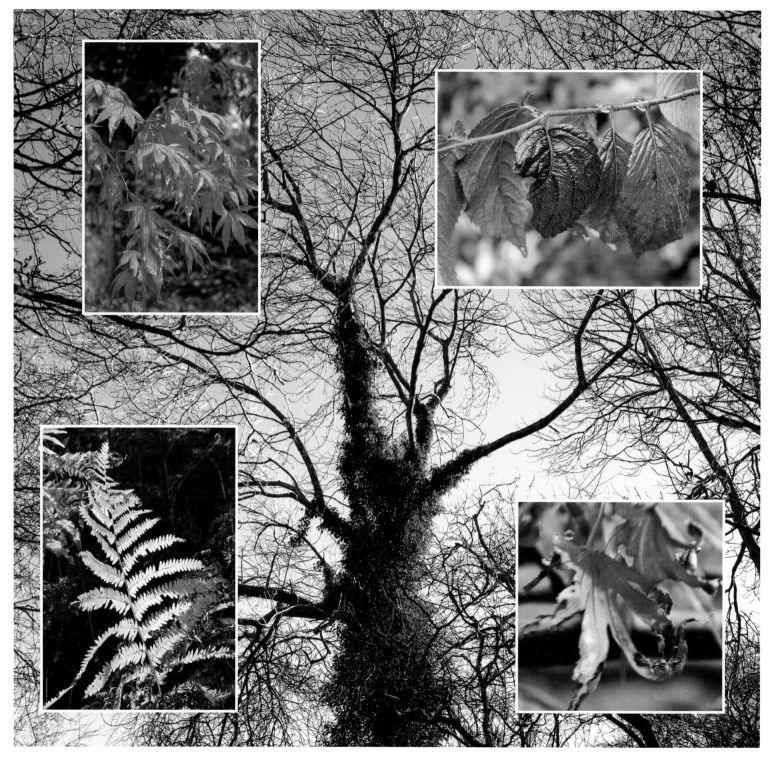

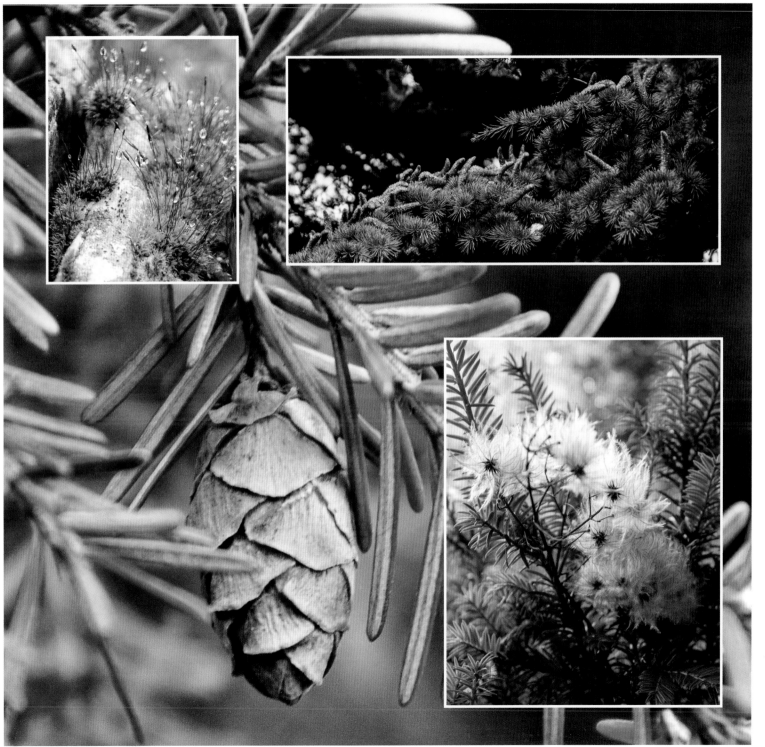

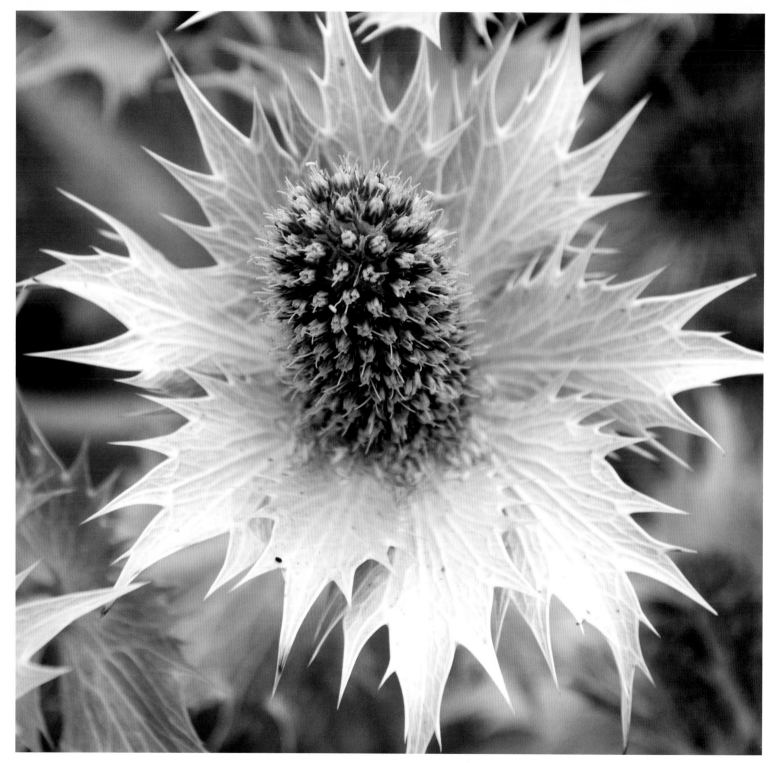

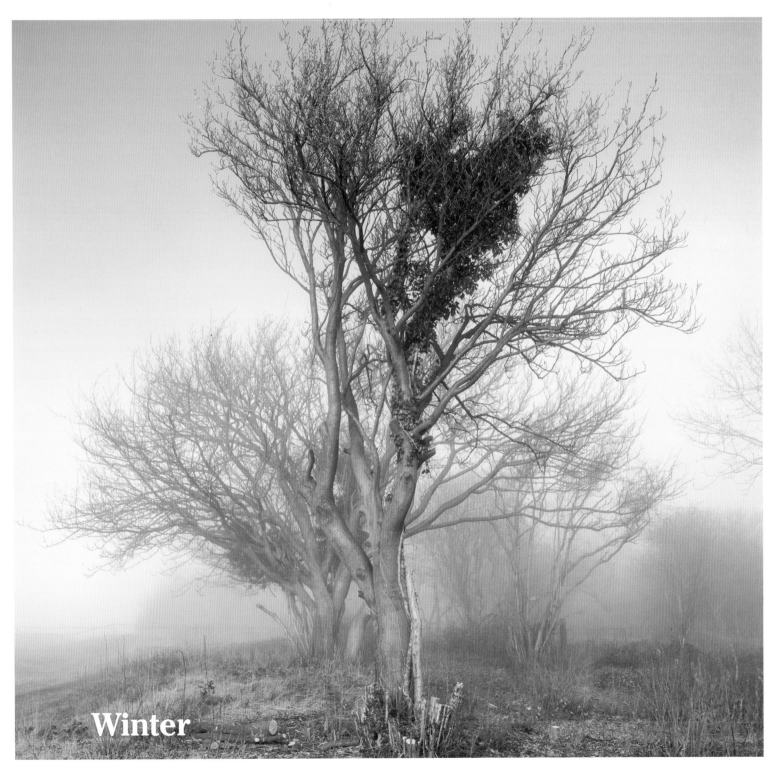

Winter

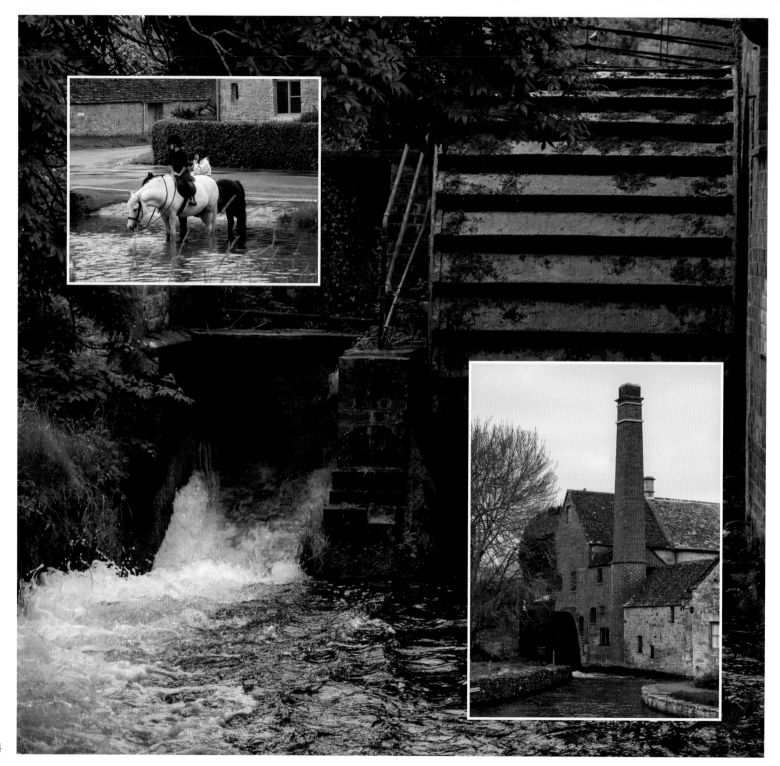

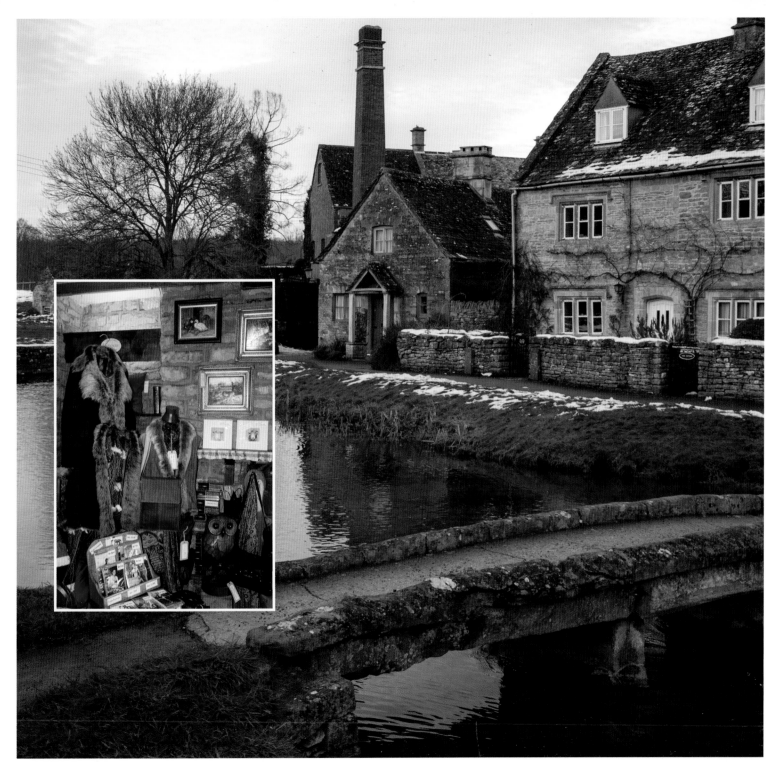

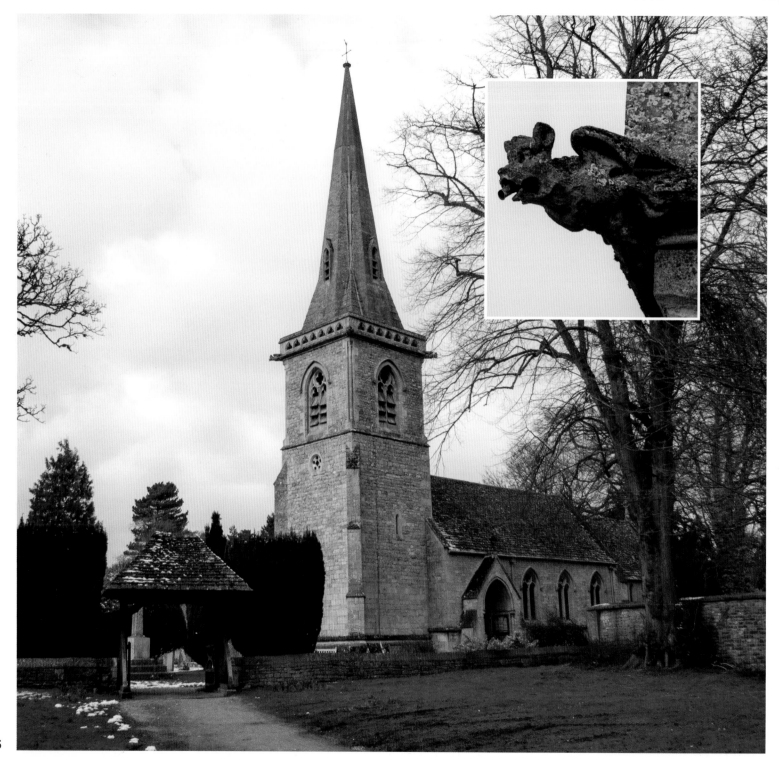

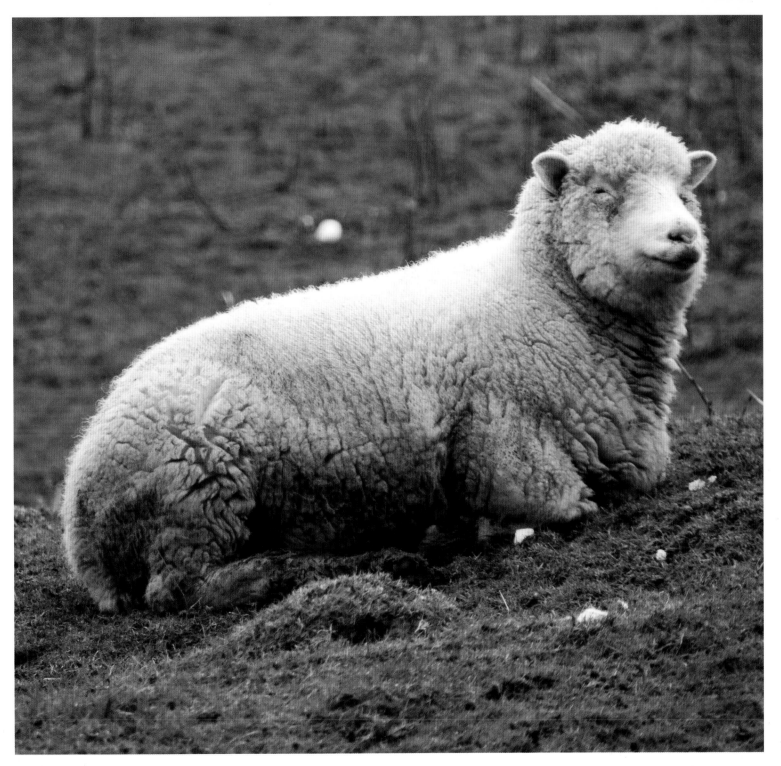

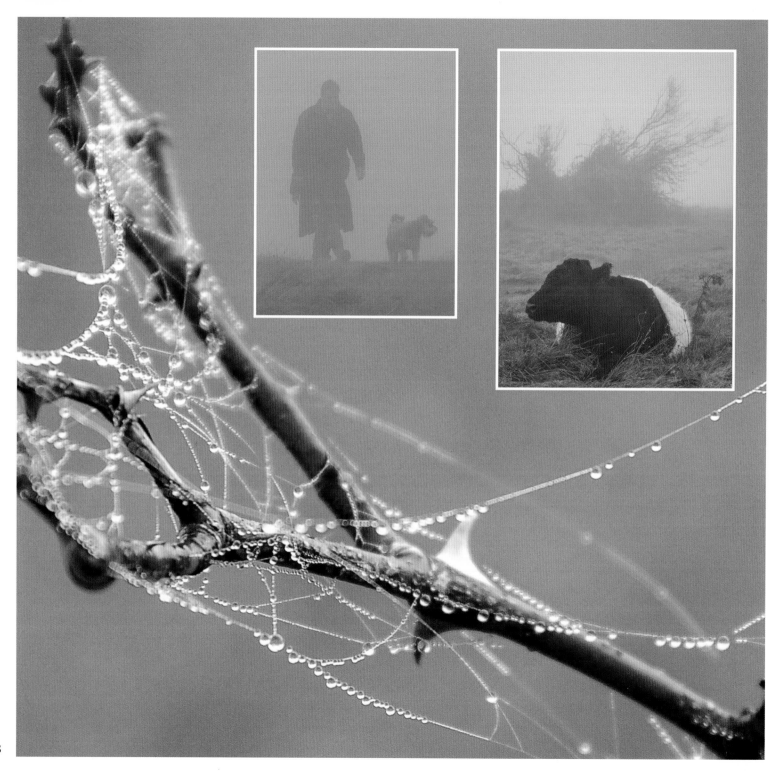

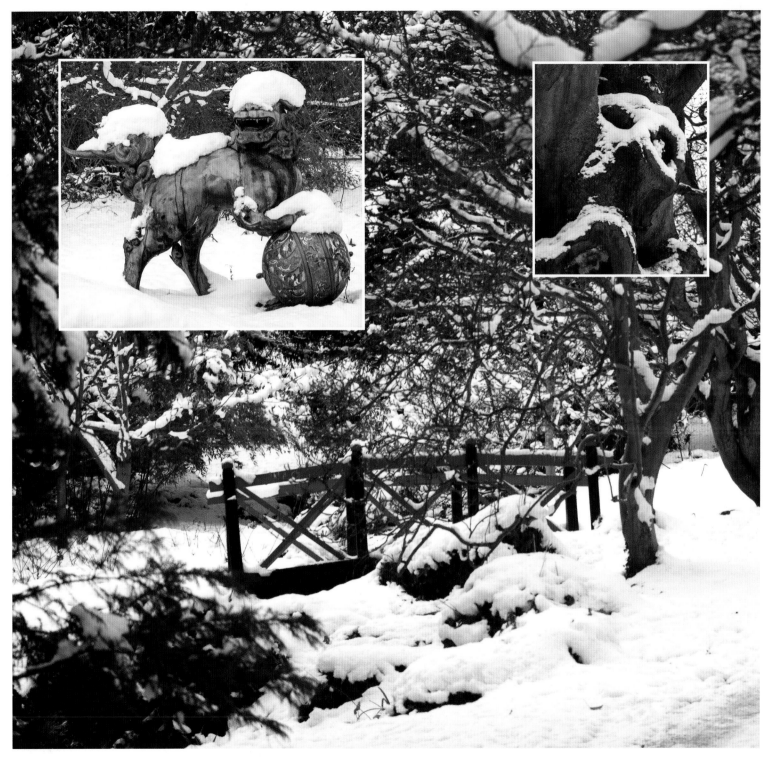

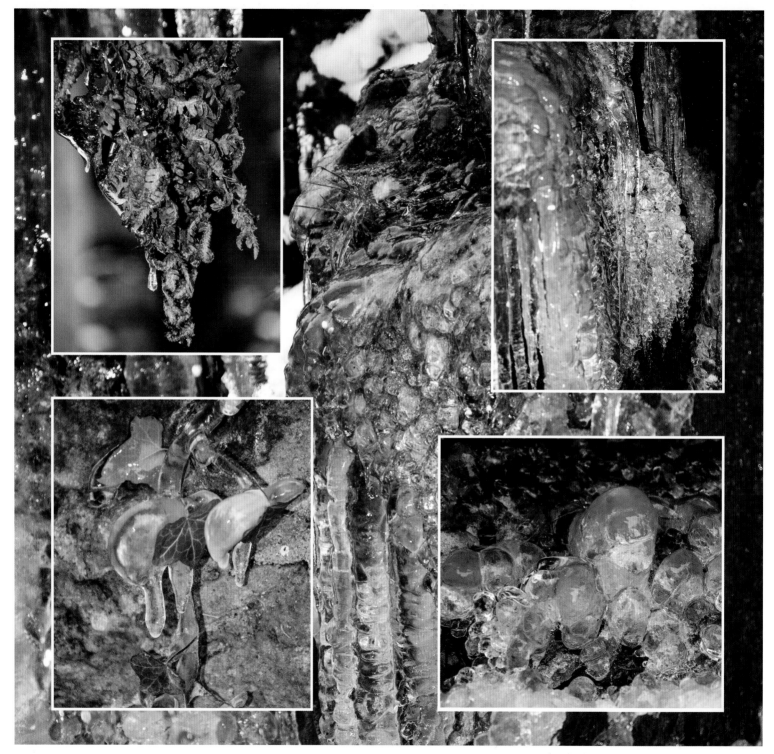

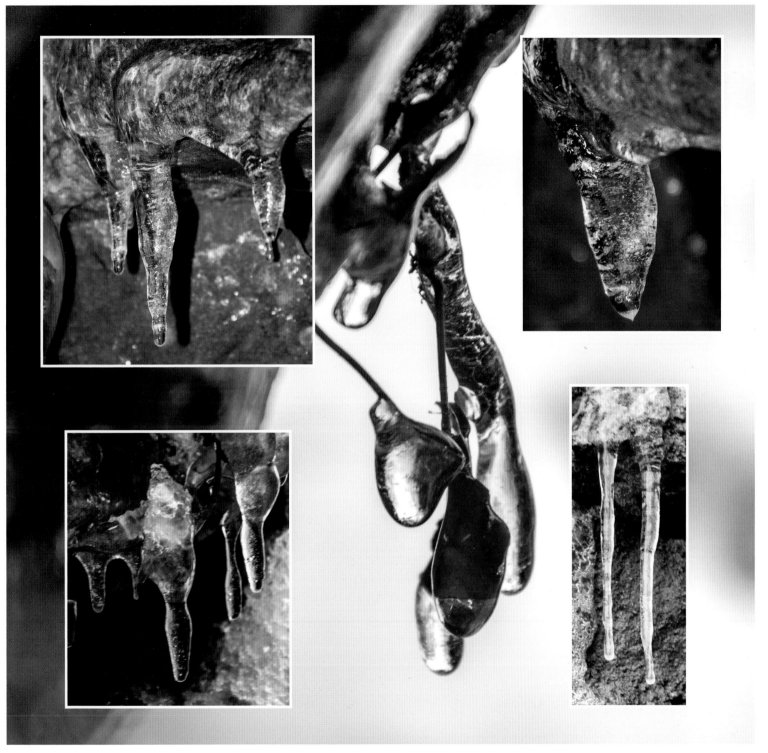

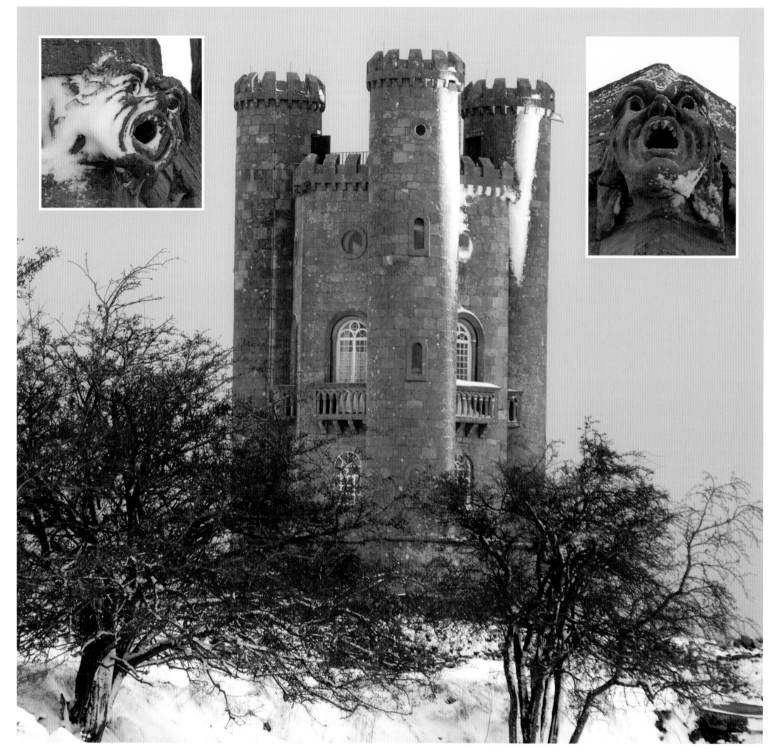

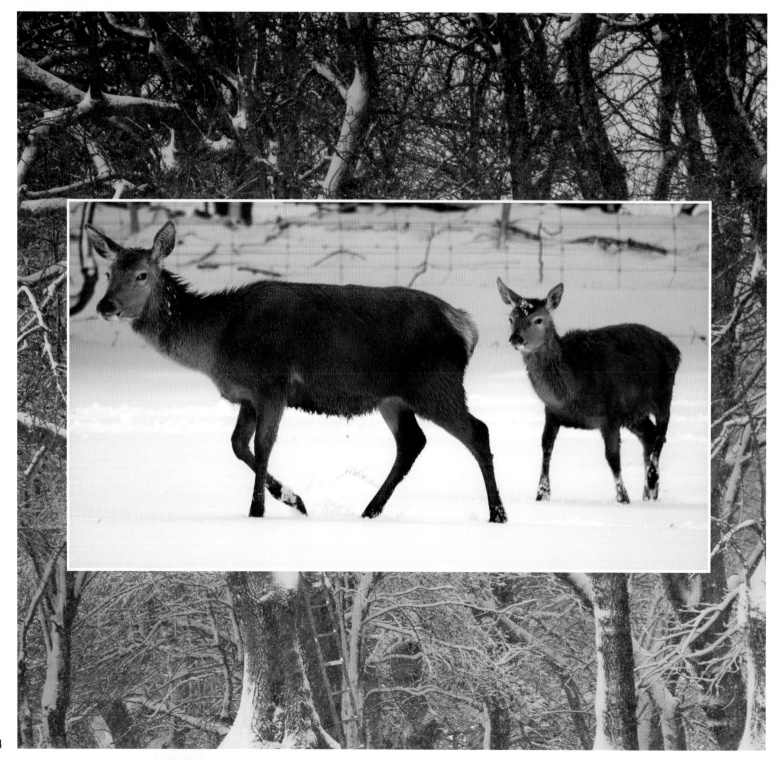

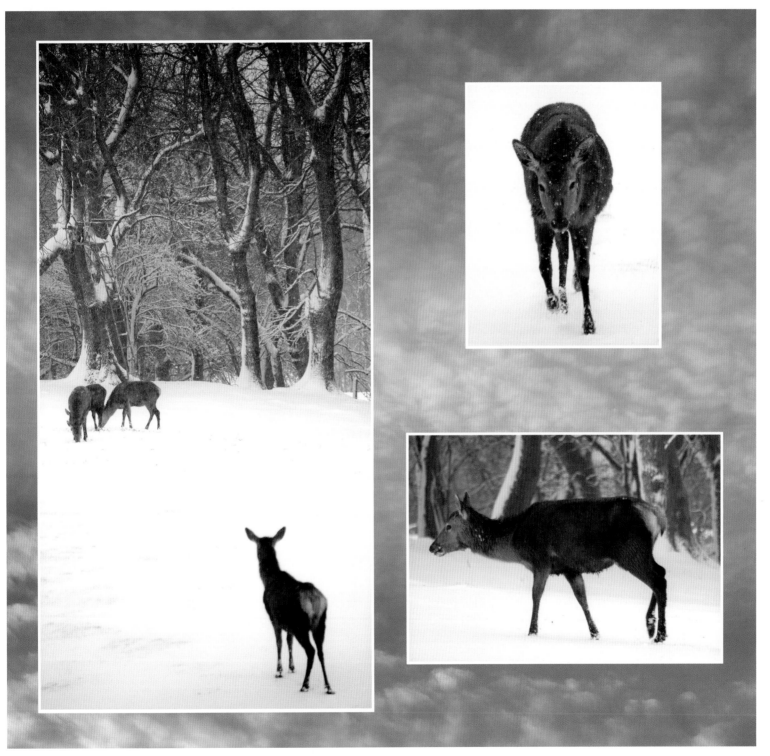

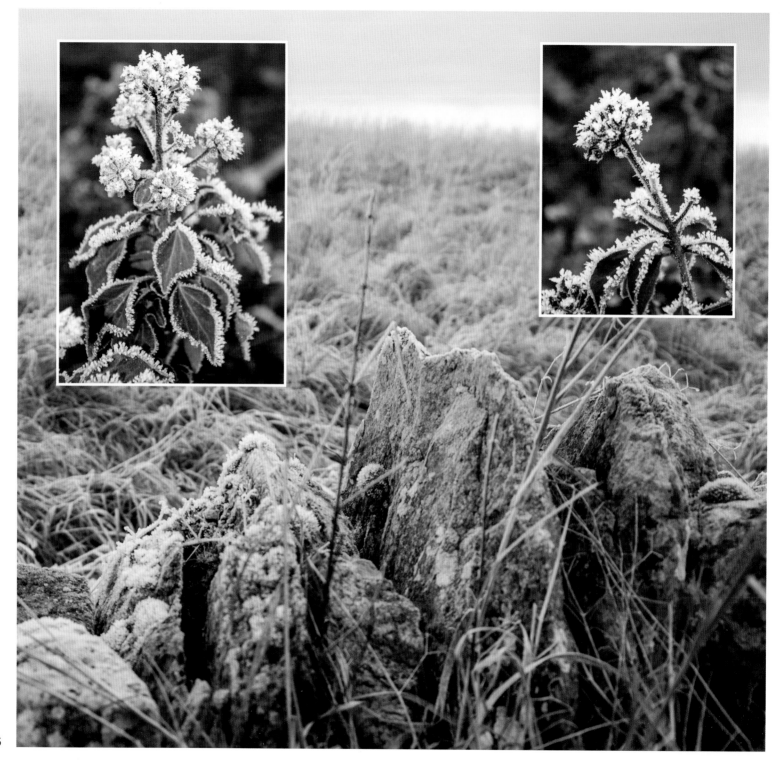

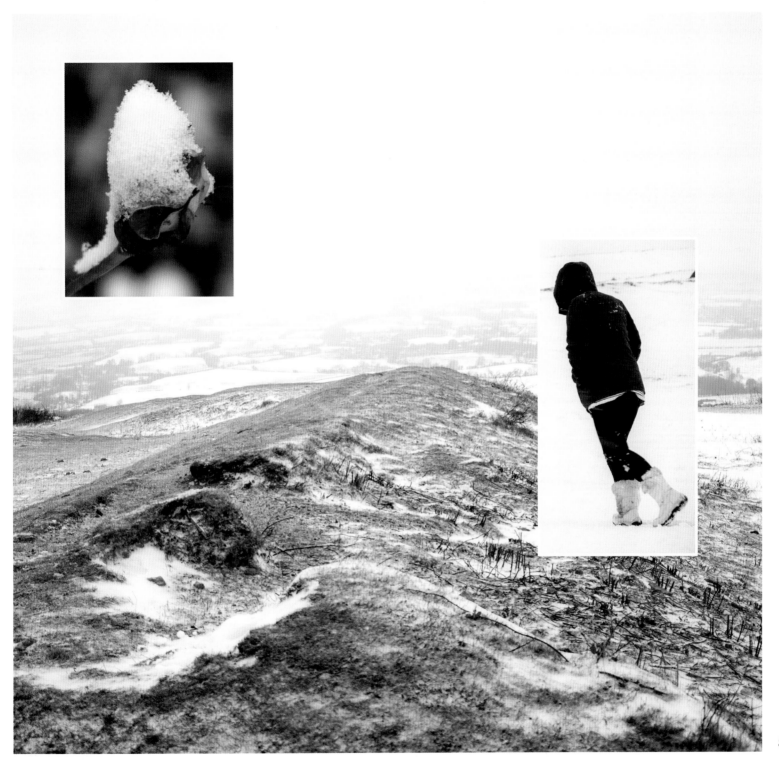

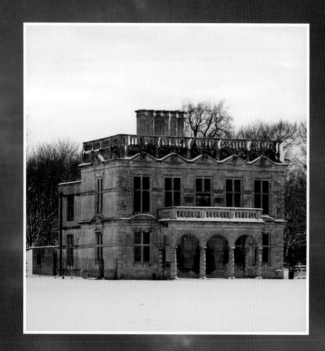

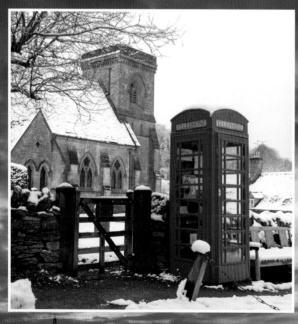

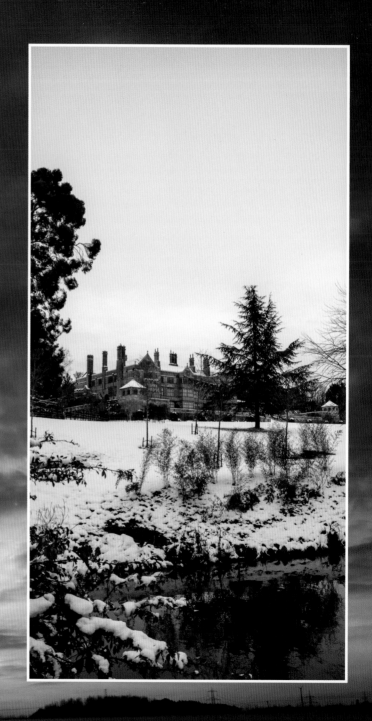

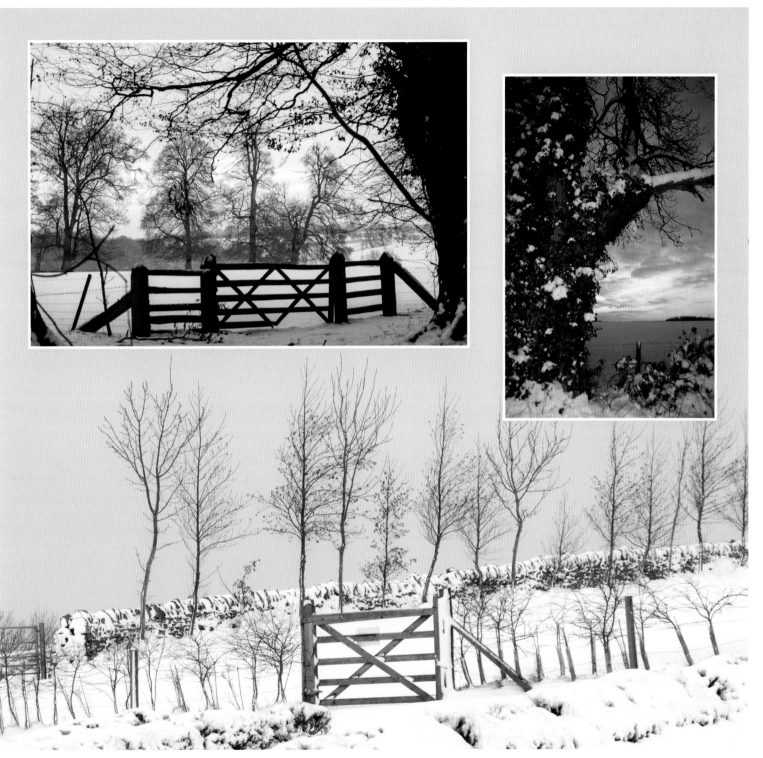

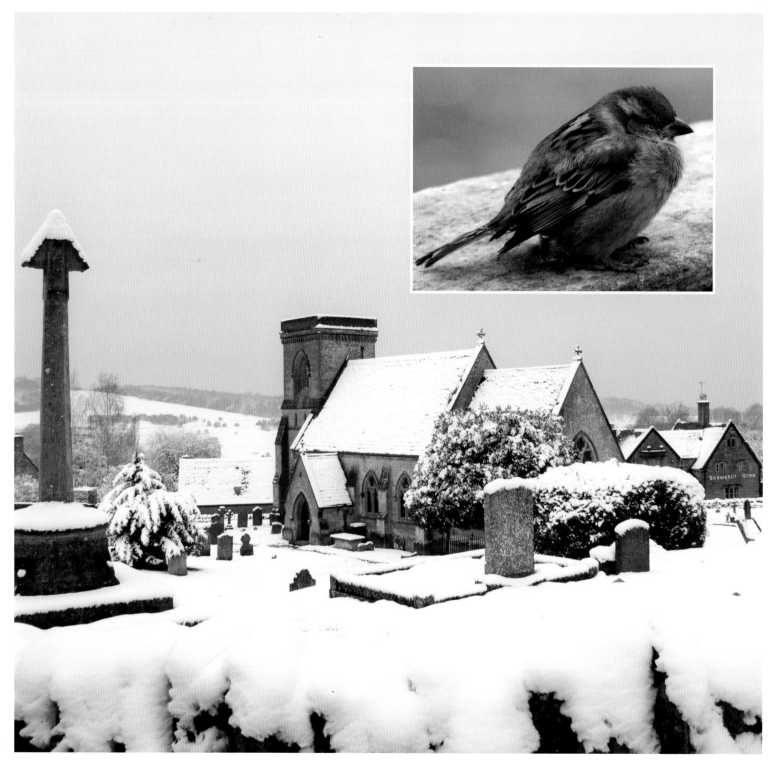

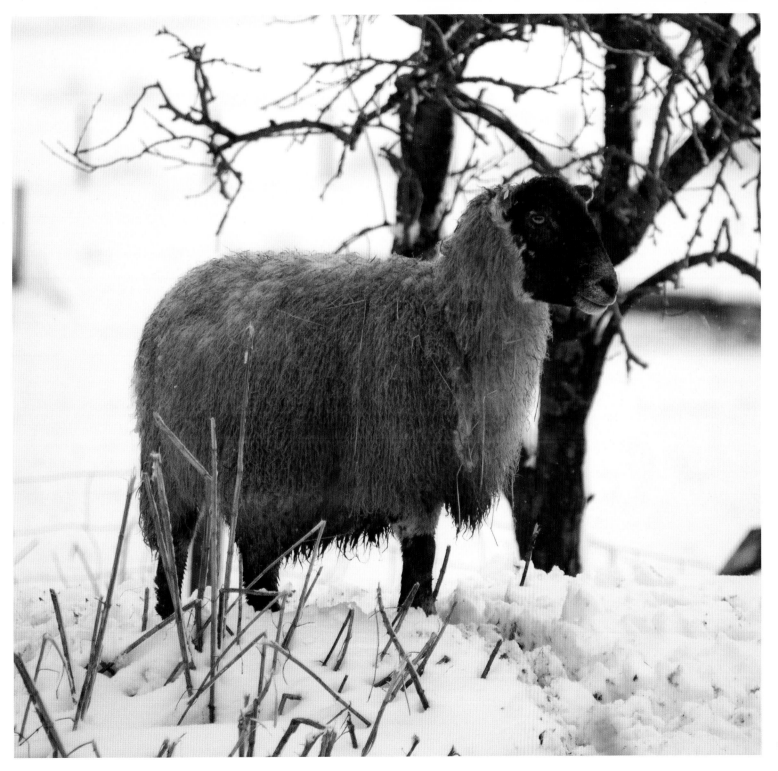

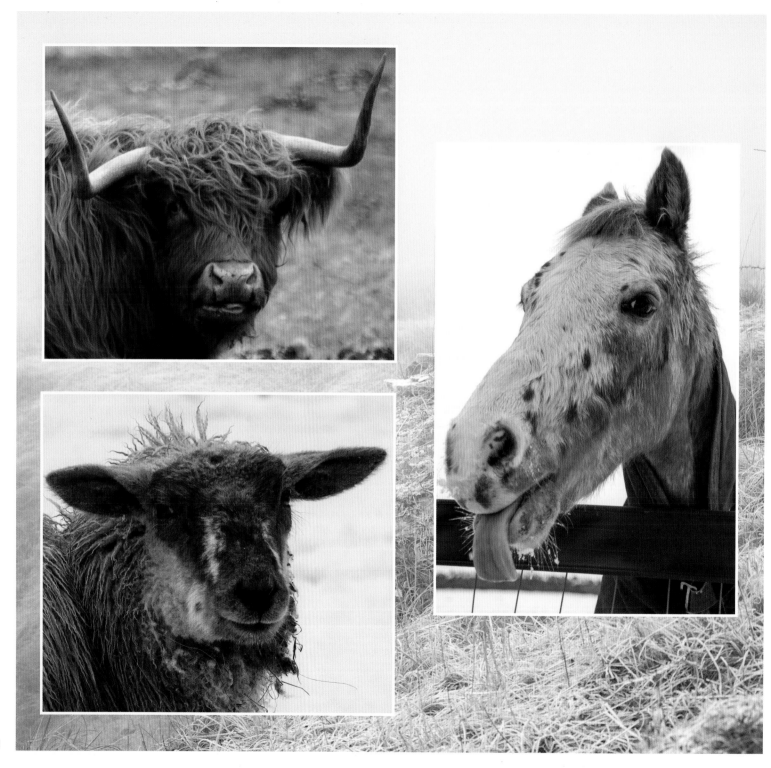

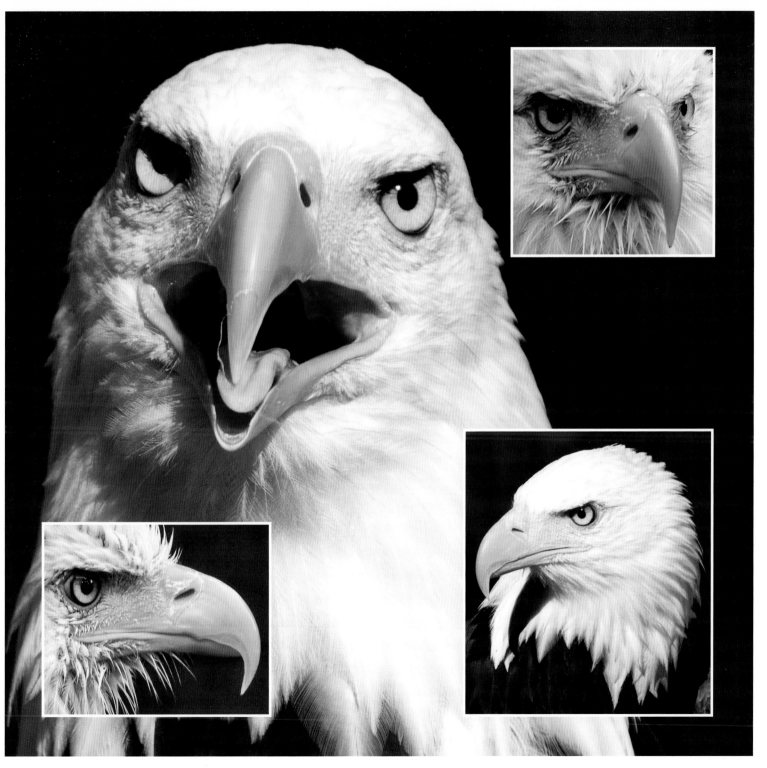

A page-by-page guide to the contents

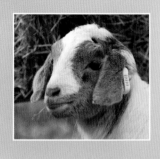

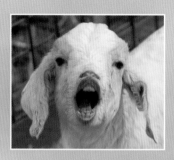

A page-by-page guide to the contents

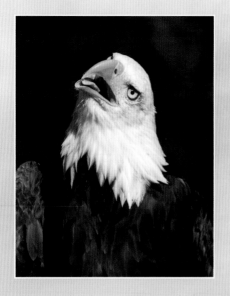

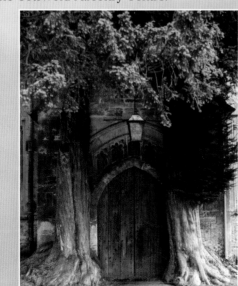

A page-by-page guide to the contents

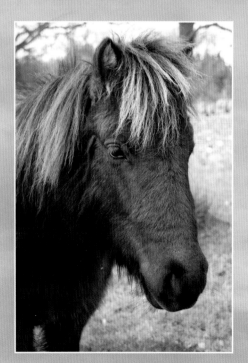

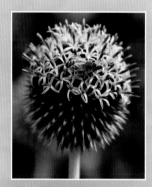

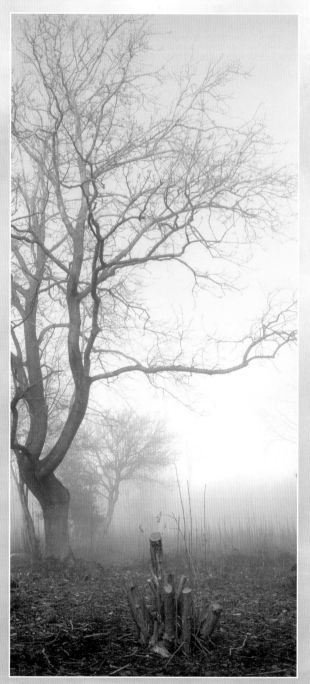